10—

ADVANCE PRAISE FOR *LIVE THROUGH THIS*

"*Live Through This* showcases a diverse sisterhood of outsiders who tackle their demons, confront their tormentors, and in turn create art that will inspire others to find the undeniable power of their own voice."

—Lydia Lunch

"This moving anthology is for any person (especially woman persons) ever addicted to drugs, madness, or self-destruction in any and all ways. It's comforting to know you're not alone, it's comforting to know you were never alone."

—Trina Robbins, author of *GoGirl!* and
Tender Murderers: Women Who Kill

"This book could save your life. Twenty dangerously smart women survive and conquer in this impassioned, inspiring All Star Slam. Look to them as object lessons, role models, creative heroines, or simply proof that you are not alone."

—Jenni Olson, writer-director of *The Joy of Life*

Live Through This
On Creativity and Self-Destruction

EDITED BY SABRINA CHAPADJIEV

Seven Stories Press
New York

A Seven Stories Press First Edition

Seven Stories Press
140 Watts Street
New York, NY 10013
www.sevenstories.com

In Canada: Publishers Group Canada, 559 College Street, Suite 402, Toronto, ON M6G 1A9

In the UK: Turnaround Publisher Services Ltd., Unit 3, Olympia Trading Estate, Coburg Road, Wood Green, London N22 6TZ

In Australia: Palgrave Macmillan, 15–19 Claremont Street, South Yarra, VIC 3141

Book design by Jon Gilbert

Library of Congress Cataloging-in-Publication Data

Live through this : on creativity and self-destruction / edited by Sabrina Chapadjiev. --1st ed.
 p. cm.
 ISBN 978-1-58322-827-2 (pbk.)
 1. Self-destructive behavior. 2. Women artists–Mental health. I. Chapadjiev, Sabrina.
 RC569.5.S45L58 2008
 362.196'85820082–dc22
 2008011098

College professors may order examination copies of Seven Stories Press titles for a free six-month trial period. To order, visit http://www.sevenstories.com/textbook or send a fax on school letterhead to (212) 226-1411.

Printed in Canada.

9 8 7 6 5 4 3 2 1

To the ones who think they are not going to make it.

Contents

Preface

It all began with Sarah Kane. She was young, cutting edge, and one of the fiercest voices in playwriting. I wanted to meet her. I had just worked on the American premiere of her play, *Phaedra's Love*, and felt that there was something in the intensity of her work that I was trying to explore in my own. Rough. Cruel. Raw. Her plays cut clean and deep, and I wanted mine to do the same.

I was in rehearsals for one of my own plays when I heard of her death. I don't remember exactly where I was at the time—probably in the theatre, making last minute additions to the text. What I do remember was the shift in me, the space slightly to the left of my heart that hurt when I heard it was suicide.

I felt betrayed, and confused. I was still in college at that point, and after years of performing assigned texts, had only begun writing my own scripts. While writing, I began to discover this strange voice at the back of my throat, which didn't sound like my old voice at all. It felt red and raw and powerful, and the more I wrote, the stronger it became. Each word seemed to chip away at my former identity and bring me closer to who I felt I really was. Writing had given me ownership over my own life. Why hadn't it done the same for Sarah?

In reality, this period of intense creation was also putting me on

the brink of my own self-destruction. Instead of simply going to classes and keggers like most of my classmates, I was scribbling manic tirades into the night, losing all sense of personal responsibility, and in this reckless freedom, barely making it through each day. I had felt a kinship with Sarah—that she had reined in this new power I was just discovering. But when I heard the word "suicide," I had to take pause: Would the same pull that led me towards Sarah Kane lead me down a similar path?

Throughout the years, I have found myself mysteriously drawn to women as brilliant and daring as Sarah Kane. Unfortunately, most of them were also self-destructive. It got to the point where it became logical: If a woman was fiercely intelligent, outspoken and passionate, I'd look towards her arms for the scars. They were almost always there.

It seemed to me that the friends and artists I felt this magnetic resonance with all had this sort of fire inside. Like Icarus, we had this strange fascination with how far into the light one could go and still come back. But we rarely spoke of these things, because we didn't need to. We had done it. We had lost control of our lives at some point, and visible or not, it had left a mark.

Perhaps we didn't talk about these things because the actual act of self-destruction is something that repulses those who do not understand it. The topic of suicide is equally kept at arm's length. Although the two can be considered different topics, both entail the act of "escape from self." People who've never desired this escape often can't fathom why someone else would. "Why would she *do* that to herself?" I remember a friend of mine violently whis-

pering to me while staring at an obviously anorexic woman. "That's disgusting."

Conversely, the topic of "self-destructive women" seems to be one that fascinates most once they're at a safe enough distance. From chronicling the meltdowns of Britney Spears and Anna Nicole Smith, to dissecting the life and works of artists who've committed suicide like Sylvia Plath and Diane Arbus, the media fuels this fascination by constantly feeding us images of tragically doomed women. The glamorization of this issue, combined with the fear and shame built around it, has made understanding self-destructive behaviors almost impossible. My friend had no frame of reference when she saw the anorexic woman; she saw someone starving herself. I saw a woman of immense power who just didn't know where to put it.

Live Through This is a collection of visual and written essays by women artists who have dealt with self-destruction, and lived to tell the story. It was initially meant to focus on what I like to call "rage to page"—how one can use the same energy it takes to self-destruct and convert it towards creation. However, as the submissions came in, the book also became a study in the relationship between creative and destructive impulses: the necessity and the balance of the two in the journey of discovering yourself.

Fairly early on, I had to establish what a "self-destructive act" was. I ended up defining it as, "when a woman *actively* takes away from herself or her power." Eating disorders, cutting, alcoholism, drug abuse and suicidal thoughts all fit into this definition. The essays also deal with periods of life (depression, mania, grief, isolation) as well as circumstances (incest and abuse) that sometimes lead us to these

actions. Finally, there is an essay on having to face the involuntary self-destruction that comes with cancer, in both the disease and treatment. A broad range of artists—cartoonists, poets, journalists, musicians, dancers, rappers, even sex writers—are represented in order to focus on the common act of creation. Hopefully, by presenting the stories of women who've dealt with so many forms of creation and destruction, we can look more closely at their relationship. How do they relate to each other? How do they play off each other? Can the same power fuel either creative or destructive acts?

Each woman has her own answer for this, though the main similarity has been that both acts instill a moment of self-reckoning, of facing oneself and using that moment as a platform for either action. Over and over, it is these moments of self-reckoning that have been significant in developing these women's distinctive voices. For some, they have served as an important stepping-stone to discovering their strengths. For others, they continue to form the base principals of their work. Either way, the self-destructive actions these women have dealt with have not doomed them to tragic endings, but instead have served as an important place in discovering their power as thinkers and artists.

We have been taught that self-destruction is an awful thing. "It is bad," we've been told by therapists, psychologists, and those who do not understand its seduction. I would like to edit that. Instead of "It is bad," I would like for it to read, "It is." It is what we do naturally. We smoke too much, we drink too much, we drive sobbing in the rain. Our hearts break and we do not eat. At times we drink to forget, and at times, we forget for years.

These are our imperfections. They are not who we are, they are simply the things that form us. I offer this book as a discourse, not as an answer, but as a way to help women begin to understand the potential in the power of their self-destructive acts. Also, as a way of speaking to my younger self, as well as any woman currently dealing with these issues in order to say this:

Now, what you're dealing with is the deepest thing, the worst thing, and it could possibly be the thing that destroys you. But it could possibly be the thing that makes you as well. I hope that these stories of incredible living artists looking back on their own journeys through self-destruction will help you realize that this is just another step in your life. It is not the end of it.

Sabrina Chapadjiev
December 2007

Long, Long Thoughts

CAROL QUEEN

When I was growing up, the world was green outside my bedroom window. The view took in nothing but trees. Evergreens started at the edge of the ratty lawn below and covered the land between my house and the highway that ran from Roseburg to Diamond Lake. Since you've probably never heard of those places, let's just say from nowhere to nowhere. Trees covered the escarpment that rose from the other side of the North Umpqua River. They were all I ever saw when I looked out, unless my view was blocked out by low-lying rain clouds or dense Oregon fog.

I loved my room. It was painted green, reflecting the only color from outside. Even the wallpaper had green roses on it, not pink. My room had beautiful furniture I got from my grandma, two four-poster twin beds and a matching vanity with a mirror on it. Antiques filled my room: it was too hard to see into the future and too unpleasant to stay in the present, so I could go only one direction, back. There was a desk, too, also painted green, situated in a little alcove. The ceiling slanted down, leaving just enough room over the desk for a bulletin

board, where I tacked up things that inspired me, quotes and cards and pictures.

I wrote at the desk every single day, keeping track of everything in a loose-leaf notebook journal with a paisley cover, though most days my life was so boring that it surprised me I still had so much to write. I amassed notebooks full of experiences that had so little to do with what I saw as real life that I was not sure how to explain why I had to fill them. I say this because real life happened outside the green-fringed mountain town, not inside it: I felt like my own life would not be real in any important way until I could leave. Sometimes I wrote in an oblique almost-code, because I did not trust that my books would be safe from prying eyes. Adding to the security, I had a secret place to stash the journal when I was done: tucked in amidst some junk in the closet that made up one wall of the little alcove where I sat at the green desk and wrote.

One of the quotations on my bulletin board read, "The thoughts of youth are long, long thoughts." This was a Longfellow line I had read somewhere, probably in one of my dad's books of excerpts of famous guys' writing.

This gave me hope that my thoughts might eventually be appreciated, because lord knows I didn't feel taken so seriously when I went downstairs. Down there I had to contend with a drunken mom who brightly tried to act like everything was fine even though it wasn't; a bitter, disappointed, and bossy dad whose future plans had never included a wife who got loaded and a kid who talked back; and a little brother who got taken even less seriously than me. At least I had a couple of teachers who paid attention, even sometimes verged

on seeming to think my thoughts might be worthwhile. In their classes I loved school almost as much as I loved my room; in the halls, though, not so much.

No one in the little mountain town thought like me. They didn't read things about the outside world. They didn't think about Viet Nam or women's rights. Outside my room, I constantly had to defend myself and the things I cared about from small-town people who didn't seem to realize that the 1940s had come and gone. The world outside exploded with war, riots, and change, and our mountain valley slumbered through it all, full of sheep and sheep-like people. I documented it all in my journal: the arguments I had with people who ignored or denigrated the bigger world out there, the desire I had to go and join that world, and the small adventures with which I passed the time while waiting.

I lost my virginity on one of the two beds, the one tucked under the slanted ceiling. It was covered with a quilt and coverlet I got from my grandmother. Tall, blond, rangy Paul James came over the day after I turned fifteen. He had never come to visit before, because why would he? He was one of the most popular guys in school and drove a green Mustang he'd never even let me sit in, much less ride in. I had a huge case of the hots for him, and I should have been truly suspicious when he told me he had a birthday present to bring me.

I knew more about sex than the next girl because my dad had a few of those books that gave hints, frustratingly obscure details, and occasional flowery between-the-lines descriptions of sex, plus I read magazine articles from Mom's *Redbook* and my *Mademoiselle* and tried to extract all the details I could. I followed up with research in

Penthouse Forum and *The Sensuous Woman* when I went to babysit; I'd figured out where all those books were in other people's houses, too. Still, I didn't have very much information about it, though I knew it was the only really interesting thing I had access to, up there in the sticks. I talked about sex at school all the time. It was the one thing that seemed to give me power in the halls, when the banter threatened to negate me or worse. Not knowing much about what I was talking about was not a problem since none of the other girls would admit to knowing *anything*. Whatever I said, the boys would run with it. This probably explained why Paul took any notice of me at all.

I had no interest in keeping my damn virginity. I wasn't saving it, for him or myself or anyone in particular. So on a day that my parents were gone, in the middle of summer vacation, in my own bed, I recognized it as an opportunity, practically a best-case scenario. Even an offhand "So, you wanna?" from Paul was a fantasy come true, proof that I could slip out of the virginity like a pair of white panties Mom bought me, finally start for real my trip toward adulthood. Even a start like that, laden with absolutely no romance, was hot because of what it meant, and as I watched him start to unbutton his 501s, for a second I couldn't believe my luck.

Despite my bluffing at school, I certainly didn't know enough about sex to find the pleasure in it, and if Paul wasn't going to let me ride in his car he surely wasn't going to go down on me, right? Plus, sex talk and bravado or not, I felt terrified at shedding my clothes in front of him, petrified at his touch. He had had sex before, probably, or maybe he had just been lucky enough to see some sexy pictures and figure out some things to try. I knew the gist, but all the details,

even what a real sexy kiss felt like, all that came as unfamiliar and even shocking stimuli. Matching it up to my expectations made me realize how simple my expectations were and how complicated this live stuff was.

The thing I didn't expect was all the positions. It was like this was in fact his first time in bed too, and he had to try them all out. I hadn't even seen enough porn magazines yet to know what he meant when he said, "get on top of me." I lay flat at first, on my back on top of him. It did not further put me in the mood when he corrected me. "Face to face!" he said. "*Sit* on me!" Sitting on him felt more comfortable than lying on him like he was a lumpy mattress—it was hard to balance on him, for one thing—but I felt so exposed astride him. In broad July daylight I could not even hide behind a shadow.

"Didja come?" he asked at the end. Still stung from my lying-flat gaffe, I retorted, "I dunno, would I have noticed?" Honestly, I had probably never been so far away from orgasm in my life. Plus I knew from my feminist books that if a guy was insensitive, he would have to *ask* you, because he wouldn't *know* . . . Even though I didn't really know what exactly an orgasm was, I knew men and women had issues about them, and even fights. I couldn't wait for him to leave, though he actually seemed nicer to me afterwards than he had during the sex, or pretty much ever. And then my broken virginity afterglow got messed with by my brother, who insisted I tell him what we'd been doing in there with the door locked.

Not long after Paul sped away down the dirt driveway in his green Mustang, throwing a cloud of dust up in his wake, I sat silent at my green desk. I couldn't bring myself to put pen to paper . . . not

yet. I couldn't because this was too private even for my cryptic code. This was *sex*, and I had done it. Paul had seen me naked, and I'd seen him, his lanky body looking even longer without his jeans and tight t-shirt. I also couldn't write because for once I didn't know what to say to myself. I had hated my virginity, and that losing it was supposed to be such a big deal. It was supposed to usher me into adulthood somehow. I did feel different now, I guessed, but I didn't feel *better*. I didn't feel sexier or more sophisticated, I didn't really feel like I knew any more than I had when we started, except what "Get on top" was.

I had done the one thing I thought would change everything, would lead me away from there somehow, and it wasn't any fun, and I didn't feel any better about my life. I felt like I had squandered my wish from the genie, like I shouldn't have pinned my hopes on this at all, like I should have picked someone not so pretty or petty as Paul. But I hadn't even really picked him—I'd just let him in.

I had no idea whether I had just experienced the sum total of what sex could give me. Before, I dreamed it would be beautiful, a revelation, it would make me feel alive and grown and sophisticated, or at least ready to learn how to be that way. If sex was what I'd felt with Paul, where were my hopes going to come from now? And not only that—all of a sudden the other things I knew about sex flooded in, and I realized he had not used a condom or even pulled out.

I looked out the window. On good days my room was like a tree-house aerie. On bad days, it was like I was Rapunzel in a prison tower. And I had just let down my hair but had not escaped. But I could not bring myself to write any of this down or even really let my

mind think the thoughts. So instead, at the top of a piece of my good stationery, I wrote the date, July 14, 1972, and then,

"Dear Abby . . ."

"I just lost my virginity. I was not expecting this guy to come over, and so I did not have any kind of birth control, and neither did he.

"Abby, I can't get any birth control at all, because I can't tell my parents that this has happened, and I have no money, and the doctor is thirty miles away and I have no transportation . . ." (Not even, Abby, a green Mustang.)

I didn't even finish the letter. I didn't mail it. But if I had, my question for her would have been simple: What do I do, Abby, what do I do?

I thought that my future would hold nothing but ruin if I was pregnant from that Kama Sutra lesson. I frantically tried to figure out what I could about cycles and fertility. Maybe that information could have been looked up in the library in Roseburg the next town over, but I couldn't get out of my tiny town to get there. I couldn't get to the doctor either. I knew about abortion, but it was illegal, so I didn't know how you would even begin to figure out where to go to get one. What would that cost, anyway? I was a kid: even if I could get money for an abortion, I'd have to answer why I needed it. No girls had babies and came back to high school. They just went away, but where did they go? It stood to reason that a guy who wouldn't give me a ride in his car would be a less-than-optimal support system. I didn't want a baby anyway—not Paul's, not anybody's. You could give a baby up for adoption, but that meant that baby lived in the world with you to haunt you forever and give you more to worry about than you

already had. My parents raise the baby? Perish the thought. Never, ever would I give them one shred of power over another creature, especially not one with my DNA. To tell the truth, I did not want my DNA to go anywhere; I wanted it to die out with me.

There was not a single option that did not add up to one thing: destroying my already half-assed life.

I don't know what day it was before the next oh-so-welcome spot of blood on my panties that I stood at the window and looked straight down. I had thought nothing but "what if, what if…" ever since Paul walked out of my house. I looked out my window that day, the one opposite my desk. Trees were almost all I saw in that direction too, that and the three-story drop down the side of the house, and concrete below.

The thoughts of youth are long, long thoughts. I would have to move one of the twin beds. The window had a screen on it, and I would have to figure out how to take that out. Or maybe cut it. With the bed shoved away and the screen cut, everyone would know it was not an accident. But I'd write a note, of course—it would be my last chance to say *anything*, I who poured out pages and pages every night. But would the drop be far enough? Would I die? If I were going to jump, it would have to kill me, not just paralyze me. If I dove, went headfirst, it would *have* to kill me, right?

Who would miss me? Should I write to people specifically, my teachers, my parents, Paul, anyone? Who would wish they'd seen it coming? Who'd say, "I thought she might do that someday"?

I went to the desk to write the note, but for once no words came.

✧ ✧ ✧

That was a long time ago.

Somehow, not being able to explain why I had killed myself kept me at the desk where I was alive, and stopped me from going back to the window, where the only direction was down. And dead.

Of course I went back to my journal. I could not write a suicide letter, and I did not dare leave snoopy parents clues, but I wrote all around it. Years and years later I realized my journals made up a long letter to myself, my future self, the only one I could really believe then would take me seriously. Somewhere on the space-time continuum the grown-up Carol already waited to hear from the adolescent Carol, waited to hold me and say, "See, we made it."

Writing bought me time and got my brain working again, so I could plan. Maybe I would just run away. When this happened to other girls they went to Haight-Ashbury, didn't they? No, I didn't feel safe running away. If I couldn't trust Paul, I sure didn't think I could trust the help of strangers.

I tried to figure out who would be safe to tell if the next month's red spot on my panties never came. I had two teachers, maybe three, I could talk to. My poor drunk mother would cry and suffer, but she would help, somehow. My angry dad would get too angry to manage. But then he probably would help too.

That pretty green house was so sad and full of stuffed-up feelings that I could not find a way to go to my parents with this. It would have felt selfish, almost, but worse, my problem would have turned into their problem, and it wouldn't have been mine anymore. I'd dis-

appear into their emotions and not be me at all, but just a trigger for an explosion, an implosion, both. All that was too much, but so was dying. And then, if there *was* anything to life, I would miss it. I would miss it unless I put my head down like a mule and stubbornly headed out for the future.

And Paul? I wish every one of you a better first time than I had, but it wasn't as bad as it could have been. I can look back today and see just two bored and curious teenagers experimenting, but at the time it carried all the weight of my future, the sex I cared so much about but suddenly found I didn't really like.

Good thing I got back on the horse. Every time I had sex after that I learned something new, not just about myself but about other people. I never really had another pregnancy scare like that, either; I learned to be careful. Plus somehow, after looking down at that chipped-up concrete landing zone, pregnancy never seemed quite so terrifying again. I've had way more secrets and adventures than seemed possible on that day when I had only one. So I never turned away from sex again, and I never thought it brought insurmountable problems, and when I finally realized I had not just been fucking, I had been *studying* fucking, I also saw I had started my whole life's work there that day, lying stacked like cordwood on top of Paul.

Sex. Having sex. Trying to understand sex. Writing about sex. Trying to help other people understand sex. Helping people break through the isolation that makes them feel they'll never, ever find love or pleasure. Thinking about the role sex plays in any one of our lives, and trying to make sense of the way we all make a culture of sexual desire, difference, misunderstanding, shame, fear, lust for

adventure. That's what I do now, and it's what people know me for doing. I guess I owe Paul a thank you for more than just the package of incense he brought along; it turned out to be the most important birthday present of my life, in a way. But more than that I have to thank the Carol who looked down at the spot she hoped would break her open perfectly, instantly, inexorably... and then turned away from the window and wrote instead of giving up on life. The Carol who turned herself into a whole person through the little scratches of pen on paper, finally found a way to escape and make her long thoughts count for something. And lived to fuck, and write, another day.

Carol Queen has a Ph.D. in sexology and is the author or editor of eleven books about sex, including *Exhibitionism for the Shy*, *Real Live Nude Girl: Chronicles of Sex-Positive Culture*, and *PoMoSexuals* (edited with Lawrence Schimel). She is the co-founder and executive director of The Center for Sex & Culture (www.sexandculture.org), is Staff Sexologist at Good Vibrations (www.goodvibes.com), and frequently speaks at colleges and universities about sexuality. She lives in San Francisco with Robert, Teacup, and Bracelet, two of whom are cats. Visit her at www.carolqueen.com.

Lady Lazarus: Uncoupleting Suicide and Poetry

DAPHNE GOTTLIEB

Like the cat I have nine times to die.*

The doctor told me it was the best option: medication. There was a pill, she said, and the pill could help. I might not want to die every second. I would not feel boiled in my own skin every moment. There was a question I had to ask, but I didn't really care what the answer was. I didn't really care about much of anything, in fact, except for not hurting. I would do almost anything not to hurt anymore. That's why I was in her office.

"Will I still be able to write?" I said to the doctor, who knew I was a writer. "Will it affect my creativity?" The doctor pursed her lips. Sunlight came through the window and flooded us. A small red light blinked on her phone. On, off, on. On, off, on. Finally, she said, "It might."

So on one hand, I had my writing. On the other, I had my life. On one hand, I had a brain drunk on malfunction, riddled with depression. On

* All section heads from Sylvia Plath, "Lady Lazarus," in *Ariel* (New York: Harper & Row, 1966).

the other, I had a brain drugged into—what? Who would I become if I took these pills? And if these pills took away writing, the only thing that gave my life meaning, well, did I even want to live anyway?

O my enemy. / Do I terrify?—

Over the course of two decades, pills of all shapes, sizes and colors have been recommended to me, pills with horror show side effects, from rapid weight gain to death. With each new prescription, my first and perhaps only meaningful question to the doctor has been whether or not it will affect my writing. I have received the same answer over and over, in different rooms, in different chairs, by different doctors.

The answer has always been, "It might."

Wanting to die—if and when the pills worked right—might stop. But the one thing I knew that I did well—the thing that gave my life a sense of meaning and purpose—might stop as well.

I meant / to last it out and not come back at all.

I wrote my first book in preschool. It was about my dog Beverley sneaking into the school and eating all the juice and crackers at snacktime.

I had my first panic attack outside my elementary school, in the winter, as I got off the bus.

When I was eight, I had my first poem published.

By fourth grade, there were days when I stayed home "sick" because I couldn't face going to school.

They had to call and call

I wrote poems. I read poems. The first time I read Sylvia Plath, I was about thirteen. She did not make perfect sense to me, but she spoke to the erosion of hope that I so often felt, the despair, the disintegration. I fell in love with Plath's *Ariel,* one poem at a time. Then I read it again. Then I wrote more poems.

Around that time, I turned a poem in to my English teacher for an assignment. I don't remember exactly what it was about, but I know that the poem was centered around a big hole in the ground, a pit with lots of bodies in it. My body was the one at the very bottom, still alive, trying to crawl out.

My mother was called in for a conference with the principal and the English teacher. Suddenly, I was forced to go to sessions with the school counselor. She said, "You seem to think you're this little spaceship, cruising along in deep space, all by itself and all alone. Well, you're not."

Well, I was.

Especially after visiting her. Everyone knew that the one thing to make you a social pariah was visiting the school counselor.

I rocked shut / As a seashell.

After the school episode, there was nowhere safe to take the things I was feeling and thinking, except my notebook. The darker things I wrote stayed there. Except when I sent them to poetry contests, which I somehow—inexplicably—won. My writing about my terrible emotional state was winning me accolades. I kept writing. I kept reading.

Like thousands of girls before me and since, I imagined my ache, my malaise, as large as Plath's and as consuming. She gave me per-

mission. She was the prescription for the doomed. And I believed I was doomed the same way she was.

Dying / Is an art, like everything else

I arrived at college baptized in punk rock and doused with hair dye. I'd never read Rimbaud but I didn't need to. I wore his *Season in Hell* like a chip on my shoulder. My heroes were dead: Sylvia, Anne. Don't we all want to be like our heroes?

Over and over, people knew I was a poet before I told them. What else could I be *but* a poet? Who else wears all black all the time?

At school, we competed daily for social status within our majors. Art majors battled to be quirky, drunk, and rebellious. Women's studies majors were earnest, disheveled, humorless. Poets were obscure and vaguely insane, or morbid. I was a poet. There were other people like me there, chain-smoking and seldom smiling. Poets. We made a noticeable pack. I do not know if we were friends.

I do it exceptionally well.

Being a good poet seemed to be more about subject matter than craft or talent, at least as far as social standing went. When other students brought in pieces about machine guns and writing in blood on the walls, I waxed on about girls auctioning off their arms for breaking, or the sounds butterflies make when they're tortured. No one called the school counselor on us. This was art, after all.

For all its cute trappings, my depression was real, pervasive, unshakable. It was eating me out from the inside and wouldn't stop, no matter how much black I wore, or even how much I wrote. I felt it

like a dark wave, its shadow looming from miles above. Sooner or later, the crest would curl like a fist, crushing me below.

At the end of that school year, the other black-clad, chain-smoking, Nick Cave-listening poets left the school. Captive to my scholarship, I stayed behind, closed my eyes, and waited for the wave to break.

I do it so it feels like hell.

Two years later, the wave broke. Everything had been going along as normal except nothing was going, nothing was normal. I had stopped eating. I had stopped sleeping. I couldn't stop shaking. I couldn't stop crying. Friends brought me, sobbing, to the doctor's office.

It was my first time in an office like that but far from the last. The doctor outlined my best option: medication. And within medication, a pill, a single pill. The pill could help. I might not want to die every second. I would not feel boiled in my own skin, wrestling to stay here but wanting out.

I do it so it feels real.

I had heard about the pills. Pills made you drool on yourself. Pills were for people who should be locked up. Pills took everything that was beautiful and exciting and drugged you up so much you didn't care. The doctor saw it as the best option.

I saw two options: Either the doctor would stop the way I was feeling with her pill, or I would stop the way I was feeling with my own pills. Other pills. Lethal pills.

It was a pill standoff.

The doctor said her pill could help. That I could come back. But did I want to come back, where there was nothing but pain, where the wave was waiting to take me and break me again?

Even if I did come back through all the pain, without writing, was there anything to come back to? Was there even a *me* to come back to?

So I asked the doctor, "Will it affect my writing?"

"It might," she said.

I took the prescription from her hand.

I did not know what else to do.

I guess you could say I've a call.

It's been a few weeks since I wrote the above, and about twenty years since I lived it, and something's wrong. I hate everything. My friends are annoying. My job is degrading and soul-sucking. And fuck it all. Fuck it. I can't write this essay.

I cancel plans. I don't return emails. I stare at the TV for a week. It's disgusting. It's all I can do. I eat junk food. I can't write. I do not want to write. Why bother? It'll just suck anyway.

I do not write.

The pure gold baby

A few years ago, I was on tour, performing at a junior high in a small town. It was the kind of town that had never seen a punk rock femme dyke before. I had performed a few pieces for the students about coping with impossible, painful things—homophobia, abuse, rape. After the reading, a small-even-for-his-age-and-already-

obviously-gay young man came up to me. He was nervous but enthusiastic as he asked me, "Does it really help to write?"

I searched his face. It was open, a little scared. His eyes glistened with his desires, his world was worlds apart from the one he had to live in.

I leaned closer to him and spoke quietly. "Yes. It does. Burn the pages if you have to," I said, "But write them. That's yours, and no one can take that away."

I told him the truth. Rather, I told him part of it: A notebook is an amazing confessional, a breeding ground, a nonjudgmental wailing wall, a home to build with your brain for every gorgeous, glimmering thing that can slip into words. It can hold some of the ugly that spills out when it's all too much.

Some of this writing is useful, good, important—it gives us insight into ourselves and our world and sometimes helps us find our way to a better place. We can make better worlds, word by word. I have written from depths of depressions, long signal flares I throw up in the air, hoping they will light the terrain around me, show me the way out. When it's working wonderfully, I get some insight or create the beginning of something that's beautiful. When I'm writing pretty well, these flares keep me busy until I'm feeling better and forget all about that notebook. Most of the time though, these flares flash, sputter, and die. Does it help? Yes. Writing helps.

But while the page can hold, the page can't heal. Pouring your heart out to a blank notebook might offer some fine, raw writing, but it does not get you the support that you need. It's not therapy, companionship, or medication. Writing is not enough, any more than my advice to the young man to write was enough. Somewhere, he grap-

pled with his problems alone. I hope he found more assistance than an out-of-town poet and a notebook.

Out of the ash / I rise

As therapeutic as it may be, barfing raw feelings onto the page doesn't make for great art either. Usually when we're depressed, we're not at our best. Our perceptions are skewed, our brains aren't working right (despite how real these perceptions feel), and we're not in full control of ourselves. These aren't great conditions to drive a car in, much less create art. In some ways, it's a little like being drunk—we say and do things that otherwise we might not.

In a depressed state, we might find a few words, a perspective, an idea that can move or delight us or just capture something elusive. But art demands control and perspective, and it's only possible to make consistently transcendent art when our brains are working right.

I do not write when I am depressed, except in a journal. And in the journal, I can see how my perceptions are skewed, I can see how I am wrong or just writing badly. On the page, I can see the dark curl of the wave, holding my most precious thing, my words, and taking them away.

In the end, it does not matter whether the pills the doctor offers will silence me or not: On its own, depression steals my words. The pills offer at least the hope that I can have them back—even for a little while. And with my words, maybe myself, too.

my heart— / It really goes.

It is late January as I write this. The sky has been alternately cloudy

and sunny on an unusually cold winter's day. And I'm writing. I have emerged from the dark cave of fuck-everything back into the electronic conversation of the internet, into playtime with my cat, into writing.

A few weeks ago, when I couldn't write, I sat before the shadow of the wave on the couch in front of the TV. But then, I called in help, friends I can trust, professional allies. I hit the marks on the responsibilities I had to and cancelled the rest. I acted as if I had a bad flu, an emotional hangover. Because I did. I took care of myself first, compassionately. It's taken me twenty years to learn how to do just this much.

But I've been reminded: This was a mild depression. The next one might not be. In the here and now, life is unremarkable. The house is messy. I am smoking too much. The sun is fussing behind the clouds. Everything is pretty good. Inevitably, sooner or later, things won't be. I won't be. And then, hopefully, I will be again.

But here in the in-between, the trick is not to look down, to continue to follow Sexton's charge to "Live, live, because of the sun," to know that Plath's Lady Lazarus did indeed rise (and eat men like air!), to wonder about what would have happened had they had more time, if medicine could have progressed just a little faster, if perhaps waves grow gentler or harsher over time, if, if, would it have made a difference; could they have made it through? From under the wave, there is only silence, but there is so much yet to be written. So here I am, sitting on the shore, watching the pill-shaped sun (live, live), writing, writing to you.

Daphne Gottlieb is the author of seven books, including four books of poetry (*Kissing Dead Girls*, *Final Girl*, *Why Things Burn* and *Pelt*), two anthologies (*Fucking Daphne: Mostly True Stories and Fiction* and *Homewrecker: An Adultery Reader*), and a graphic novel (with artist Diane DiMassa, *Jokes and the Unconscious*). She lives in San Francisco and teaches at New College of California.

Fighting Fire with Acid Rain: A Story on Coming Down

CRISTY C. ROAD

FIGHTING FIRE WITH ACID RAIN

A STORY ON COMING DOWN BY CRISTY C. ROAD

"*STAY AWAY FROM THOSE NASCENT DEMONS,*" MY CONSCIENCE TOLD ME WHEN BIDDING ME FAREWELL BEFORE ANOTHER MORNING'S SLEEP. AND BY NASCENT DEMONS, I KNEW MY CONSCIENCE MEANT COCAINE. CRANK. *HAPPY FUCKING DUST.* ANYTHING THAT KEEPS ME AWAKE BESIDE A NUMBING REALITY. ANYTHING WITH A COMEDOWN THAT ACCENTS A PLETHORA OF EMOTIONAL ABSENCE. DEPRESSION. BARE BONES SPRITZED WITH A SENSE OF LOSS- OR NO SENSE AT ALL. SO, I'D JUST DO MORE- AND COME UP ROSES.

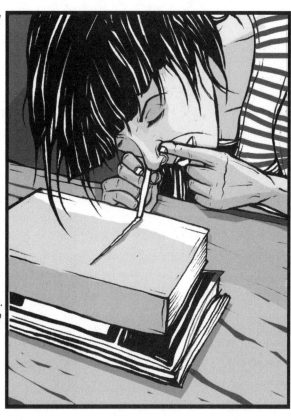

IT WAS A SAFETY MECHANISM. TO KNOW THAT FOR A MINUTE, AFTER A SWIM THROUGH MY FAVORITE WHITE STREAM, NOBODY MOURNED. ALL THE BAGGAGE THAT DEBILITATED THE LAST TWO YEARS SHRIVELED. FOR AN HOUR, NO FRIENDS HAD DIED. FOR A DAY, MY TRIBULATIONS WEREN'T DIVIDED ON OPPOSITE PLANES, BATTLING ONE ANOTHER. BECAUSE FOR A DAY, THE PORTALS IN MY BRAIN WERE PRECISELY FITTING INTO ONE ANOTHER, LIKE WELL-TRAINED BALLERINAS. AND FOR THE NIGHT, I WAS SEXUALLY CONFIDENT AND THE AFTERMATH OF ABUSE SAT IN THE CORNER WITH THE OTHER PUDDLES OF SPILLED MILK. COCAINE WAS A SHEATH OF COMFORT DECIMATING ALL CORNERS OF DESPAIR. IT WAS THE LITTLE CALLOUS THAT TOLD ME TO CONCEAL WEAKNESS- ABOLISH CONFLICT FOR A FORGED SENSE OF PRIDE AND LEAVE CONFRONTATION FOR SOBRIETY.

"FUCK SOBRIETY THIS YEAR." I TOLD MYSELF TO TIP TOE OVER MY LANDMINES AND LEAVE CONFLICT FOR TOMORROW. IN A THOUGHTFUL TAKE ON PROCRASTINATION, I DID ANOTHER RAIL AND GLEEFULLY RAN WILD.

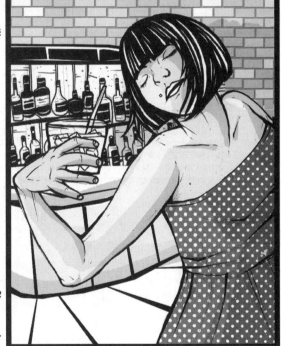

AT A STAGGERING 8AM, I COULD FIND LOVE AMONG THE LONGEST OF RAILS WITH THE MOST PECULIAR OF PEOPLE. ON A BLOWN-OUT STREAM OF CONSCIOUSNESS, I COULD INTERSECT WITH ANYONE. I COULD HEAL FLAWLESSLY WHILE STILL NOT HEALING AT ALL. CONNECTION AND HEALING WERE MY CATALYSTS. THERE THEY SAT, COMFORTABLY IN MY PSYCHE- SO FALSE, BUT SO SIMPLE.

"IF I COULD STABILIZE MY BRAIN LIKE THIS, THEN I COULD MISTAKE MYSELF FOR SANE, I THINK, " I TOLD MYSELF ONE NIGHT, KEYING A BUMP UP MY LEFT NOSTRIL BEFORE HEADING TO SOME BAR ON AVENUE B AND FOURTH ST. I PEERED TO THE LEFT AND SAW THE GLASS CASING OF MY RECORD PLAYER TEETERING ON THE EDGE OF AN UNINTENTIONAL SHATTER AFTER MY FIFTH RAIL. I REACHED FOR MY JACKET, AND NOTICED MY CABINET WAS EMPTY OF ANY NUTRITIONAL BEARINGS. I WAS FUELED ON CHEWING GUM AND TWO-FOR-ONE CANNED SOUPS.

IT HAD BEEN MONTHS SINCE I FACED MY REAL LIFE. I WAS BLINDED BY HOW SIMPLE HUMAN CONNECTION WAS WITH BLOOD PUMPING AT TWO- HUNDRED MILES AN HOUR. ON 4TH AND B THAT ONE NIGHT, I FOUND A PRETTY FACE, GRABBED HIM BY THE WRIST, AND WALTZED HOME WITHOUT DESPAIR. A NEW LOVER WAS THE ANSWER TO CONNECTION, I THOUGHT.

AFTER ANOTHER RAIL THAT FRIDAY NIGHT, I ASKED THE STRANGER TO KISS ME. I FELT THE BLOOD SETTLE BENEATH MY PUPILS AS MY BRAIN EXPANDED WITH A FORGED SENSE OF WISDOM. THE WISDOM, AS FALSE AS EVER, WAS UNSTOPPABLE. HIS TONGUE WAS INSIDE OF ME, SOOTHING THE NUMB SENSATION COWERING BETWEEN MY TEETH AND MY THROAT. HIS FINGERS WERE A THRILL AS I FELT HIS GENTLE MASSAGE ON MY SHOULDERS TRICKLE LIKE LIGHTNING BETWEEN MY LUNGS AND MY PUSSY. SEX DIVERTED ME ON THAT FRIDAY, AND I HIT A SPEED BUMP. THE COCAINE SHIFTED FROM PHYSICAL TO CRANIAL AND I SUDDENLY FELT A TENDER AND SUBMISSIVE ADORATION FOR THIS LOVER; THIS STRANGER WHOS HANDS MANEUVERED BETWEEN MY BEDPOST AND MY CACKLING LIMBS. FLASHES OF A DAMAGED PAST WERE RESURRECTED AS I CAME DOWN.

"I NEED YOU" I SAID IN A BINGE TO MY LOVER.
"I HAVE TO GO. I HAVE WORK AT 8. HAVE AN AWESOME DAY." I WALKED HIM OUTSIDE AND STUMBLED BACK INTO MY ROOM. *"I LOVE YOU,"* HE SAID TO ME, AND I SMILED. PART OF ME JUST THOUGHT- WHO IS THIS GUY? I SAT MOTIONLESS. MY BRAIN RAN FREE, THROUGH THE TIME BOMBS, THE DEATH TRAPS, AND THE MINEFIELD THAT WAS MY LIFE. THE BOMBS SET OFF, AND I MISSED MY LOVER. THE YEARNING INTER-MINGLED WITH LOSING MY COMPLETE SENSE OF SELF.

"WHERE AM I?" I ASKED MYSELF ONE DAY, SITTING ON THE FOOT OF MY BED. "I CANT FEEL MY HANDS. IM A CORPSE WITH A NEWLY OPENED CAN OF WORMS AND THE FUCKING WORMS ARE ALL OVER ME." I GRABBED THE EDGE OF MY BEDPOST AND DRAGGED MY BODY BENEATH THE SHEETS. IN A SQUANDERING SECOND OF SINKING BACK INTO MY BODY; I REMEMBERED EVERY LIFE QUALM I TRIED SO HARD TO CONCEAL. THE LITTLE PULSES THAT COCAINE HELPED ME FORGET. THE LITTLE PULSES I WANTED TO DIVE INTO, HEADFIRST, WITH HUMAN COURAGE UNASSISTED BY BLOW. BLOOD SEEPED FROM MY NOSTRIL TO MY LIP AND I COULD TASTE IT. AS THE BLOOD SETTLED ON MY RECHARGED TASTE-BUDS, I REMEMBERED THAT I HAD A PULSE. I REMEMBERED THAT COM-PROMISING A CONNECTION TO MYSELF IN ORDER TO MAKE TURMOIL TEN SECONDS SIMPLER WAS NO LONGER WORTH IT.

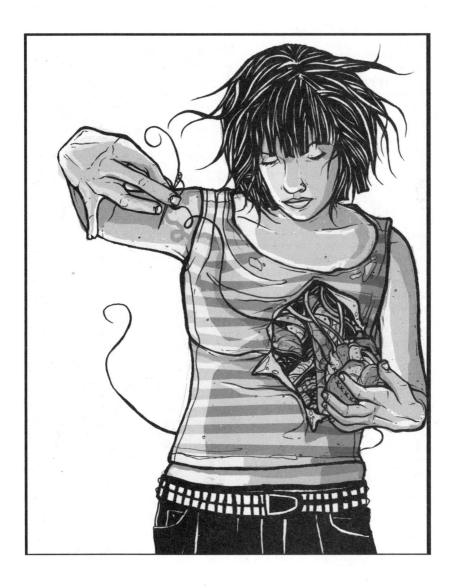

I TURNED TO THE WALL AND FELT DECAYED. MY PALMS WERE SWEATING AND I HELD THEM TOWARDS THE CEILING FAN.

THE MORNING AFTER, I WOKE UP TO REALIZE I MISSED A SECOND DEADLINE THAT WEEK. I REMEMBERED I WAS AN ARTIST, AND WORKING ON MY ART COULDN'T HAVE POSSIBLY BECOME A *DULL CHORE-* WHERE DID I PUT MY FIRE, THE NATURAL ONE EMBEDDED IN MY SOUL WHEN ITS PURE? WALKING OUT TO THE FIRE ESCAPE, I PEERED AT EVERY PASSERBY AND WAS REMINDED THAT PEOPLE DIE. THE HEALING PROCESS SHOULD HARDLY BE CHARACTERIZED BY A CHEMICALLY FALSE HOPE, I TRIED TO TELL MYSELF. I WANTED TO CLUTCH MY INNARDS AGAIN- NOT WITH A PULSE AT THE PACE OF SPEED, BUT AT THE PACE OF MY HEART. *WAS THIS TRUTHFUL PROGRESS* OR ANOTHER SEVEN MINUTES IN A HEAVENLY NUMBNESS? JUST THEN, I FELT CLEAN FOR THE FIRST TIME IN MONTHS. IT HAD BEEN 72 HOURS SINCE MY LOVER LEFT ME ALONE WITH MY BRAIN, AND SLOWLY I TRIED TO BE ME AGAIN. THE SUNLIGHT THROUGH THE GLASS SHONE ON THE PAGES OF WHAT I WAS SUPPOSED TO BE DOING. PAGE AFTER PAGE, MY ART FINALLY WENT SOMEWHERE. BLOW WAS THE EDGE OF A SWORD THAT DANGLED JUST A FOOT AWAY FROM ME, BUT HERE FINALLY CAME CREATIVITY TO THOUGHTFULLY GET IN ITS WAY.

"IF I DIDN'T HAVE TO STABILIZE MY BRAIN LIKE THIS, THEN MAYBE I COULD WRITE IT OFF, ATLEAST," I TOLD MYSELF, LOOKING ONTO MY BLANK PIECE OF PAPER, ON A DAY WHEN NUMBNESS HAD BECOME A LITTLE LESS OF A CURE.

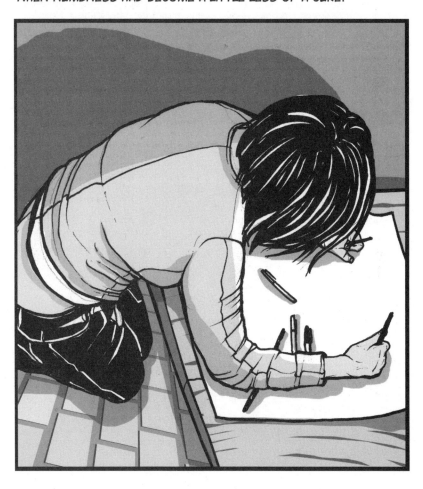

Cristy C. Road has been illustrating ideas, people, and places ever since she learned how to hold a crayon. Her endeavors in illustrating and publishing began when writing the punk rock zine, *Greenzine*. In early 2006, Road released an anomalous illustrated storybook titled *Indestructable*. She's also paired up with filmmaker Esther Bell to create a series of illustrated novels based on Bell's upcoming film, *Flaming Heterosexual Female*. Road has recently completed a collection of postcards featuring art from 2001-2007 titled *Distance Makes the Heart Grow Sick* (Microcosm Publishing). Currently, she's working on *Bad Habits*, an illustrated love story about a faltering human heart's telepathic connection to the destruction of New York City. With no obvious means to slow down, Road currently hibernates in Brooklyn, New York, and will possibly venture into the world of art galleries, but would much rather not think too much about the future.

A Little Hell Breaks Loose

PATRICIA SMITH

My mother bled moans for hours before I was born, the tortuous labor enough to shake her legendary belief in a merciful Jesus. For years, my father told the story of how I constantly pummeled the air with tiny fists, already expecting enemies to inhabit my first anxious days.

If we here were to write the headline, it would be *A LITTLE HELL BREAKS LOOSE* and her name is Patricia, three downbeats in a line of song, Patricia Ann, four no-nonsense syllables that stamp me a tenement occasion, one more assembly-line brown sugar beginning a first generation up north. Cave-jowled Mayor Daley might as well have been my daddy.

Oh Mary Mac Mac Mac
All dressed in black, black, black
With silver buttons, buttons, buttons
All down her back, back, back
She asked her mother, mother, mother
For fifteen cents, cents, cents

47

To see the elephant, elephant, elephant
Jump the fence, fence, fence
He jumped so high, high, high
He touched the sky, sky, sky
And he didn't come back, back, back
Till the Fourth of July, ly, ly

Teasing milk-and-sugar social programs drove my parents into each other's arms, hot at the thought of creation, driven by that American dream of birthing a colorless colored child with no memories whatsoever of the Delta.

My grandmother, silvery Cherokee, rocked me to sleep with forbidden songs, told me tales of whole lives ruined by broken branches, dead flowers and bits of bone tied in cotton pouches. She was all the Alabama I had, while my mother clogged my scalp with sweet grease, hot-combed my hair to the point of flame and instructed me in the painful silk of little white girls.

Mama pinched my nose so it wouldn't be so flat and broad, made me pronounce things right, prayed I hadn't inherited her lazy Alabama tongue. *Girl,* she said, *stand up straight, act right in front of white people, and I hope you know you can't swivel them hips if you intend to walk with the Lord.*

Daddy, Otis D, Westside rogue, renegade, spent days in the candy factory with his arms plunged up to the elbows in vats of sweet chocolate, spent steamy Chicago nights tipping out, shit talking, poker playing, mumbling his homemade blues into the closest cheap microphone:

You see that front door, baby?
You can bet it's made of wood.
Can you see that front door baby?
You can bet it's made of wood.
And when I twist that doorknob,
you can bet I'm gone for good.

Daddy taught me how to slap cards on the table like I'd already won the damned game, how to swivel my hips when the Lord was looking the other way, how to soak up shots of Jim Beam and still know my full Christian name at the end of the night. I stitched myself to his side and followed his every lead, slicing damned-near-fatal hot peppers into my collard greens, crowning BB King savior, ignoring mama and cookin' for my damn self after Daddy taught me hot water cornbread and tabasco on everything.

Umm, sugar smelling man showing off his baby girl, and *wait a minute man, listen to these big words she knows, go on, say 'em for 'em, baby, sound just like a white girl, don't she?*

I fell in love with him, followed him around with his hardhat on my head, woulda died for my daddy. He convinced me I was born to be begged for—so my favorite music came from Motown highstep-pers who were always begging you not to go, whining because you'd left them after they'd begged you not to go or praying out loud that you would come on home so they could beg you not to go before you left them again. He sang "Ain't Too Proud to Beg" with me, off-key so I'd feel at home, and when the record player got tired, he stood over my shoulder while I wrote stories in wire-bound theme

books, stories where every character was me, but me with different names and me making them say anything I wanted.

The blame ain't layin' there, though.

Hey, you know, my first slow dance was with a friend of my daddy's? While Tyrone Davis begged *baby can I change my mind,* I swooned under the stench of bad intentions and Hai Karate, and winced at the hard-on we both tried to stop. *Growing up too damned fast,* my mother would say, *know too damned much.*

Knew more than she thought I did, cause I finished that dance.

When I was just a little thang, gangly legged and groggy with my timetables and the rust smell of boys, Daddy read me newspaper stories, where right down the street at the Graymere Hotel that man we saw every Saturday at Slick Style barbershop was jacked up and damn just like magic there was his name, his real name that he never told anybody, and enough of his business in the paper so that everybody knew who did the jackin' up and why. Ain't that magic, ain't that magic? I thought my daddy had wrote those stories cause why couldn't he cause he wrote me poems on the back of cocktail napkins before he was dead he wrote stilted verse with every line rhyming at the end before he got shot in the back of his head he told funny little stories starring a little girl named Patricia and right in there close enough to touch he'd throw in Barbie and Mary Poppins and the Green Hornet and even Martin Luther King and had me talk to them and them talk to me before that boom blew him up he read me headlines and terse lines of type like they were fairy tales and there was no reason for me not to believe, no reason to believe not to believe, he built me a world before he left

this one, he built me a world and said *baby girl crawl inside,* before that bullet opened him up and made all those stories spill out, before he hit face down on that dirty maroon carpet, that carpet so dirty and so maroon that the blood from him mixed in it and disappeared, so at first it looked like he had died clean like in those Saturday afternoon cowboy movies, just one perfect hole in him, one huge hole that took away his head, Lord yes, look like he had died righteous, clean and no blood and straight on to heaven like a white man.

If a frustrated blues man falls in a Chicago tenement with no one there to hear, does he make a sound?

If his mouth is blown out of its place on his face, can he still sing?

If he's kinda dead, does he still have a daughter?

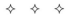

The recipe for hotwater cornbread is simple—corn meal, hot water.
Mix till sluggish, then dollop in a sizzling skillet.
When you smell the burning begin, flip it.
When you smell the burning begin again, dump it onto a plate.
You've got to wait for the burning and get it just right.
Before the bread cools down, smear it with sweet salted butter
and smash it with your fingers, crumble it up in a bowl of
collard greens or buttermilk. Forget that I'm telling you it's the
first thing I ever cooked, that my daddy was laughing and breathing
and no bullet in his head when he taught me.

Mix it till it looks like quicksand, he'd say, till it moves
like a slow song sounds. We'd sit there in the kitchen,
licking our fingers and laughing at my mother,
who was probably scrubbing something with bleach,
or watching Bonanza, or thinking how stupid it was
to be burning that nasty old bread in that cast iron skillet.
She always used whole milk and eggs and baked her cornbread
until it was plump and sugary, and she'd branded me hopeless
as a homemaker, too damned interested in sitting in the kitchen
in the half dark, learning nothing at all from a man
who had other women and stayed out late on Saturday nights.

When I told her that I'd fixed my first-ever pan of hotwater corn-
 bread,
and that my daddy had branded it glorious, she sniffed
and kept mopping the floor over and over in the same place.
So here's how you do it.
You take out a bowl, like the one we had with blue flowers
and only one crack, you put the cornmeal in it.
Then you turn on the hot water and let it run
while you tell the secret about the boy who kissed your cheek
after school, or about how you really wanted to be a reporter
instead of a teacher or nurse like mama said, and the water
keeps running while daddy says you will be a wonderful writer
and you will be famous someday, and if I wrote you a letter
and sent you some money, would you write about me?
And he is laughing, and breathing, and no bullet in his head.

So you let the water run into this mix until it moves like mud
 moves
at the bottom of a river, which is another thing daddy said,
and even though I'd never even seen a river, I knew exactly
what he meant. You turn the fire way up under the skillet
and you pour in this mix that moves like mud moves
at the bottom of a river, like quicksand, like a slow song sounds.
That stuff pops something awful when it first hits that blazing skil-
 let,
and sometimes daddy and I would dance to those angry pop
 sounds,
he'd let me rest my feet on his and we'd waltz around the kitchen
while my mother huffed and puffed on the other side of the door.

"When you are famous," daddy asks me, "Will you write about
 dancing
in the kitchen with your father?" I say everything I write will be
 about you,
then you will be famous too, and we dip and swirl and spin, but
 then he stops
and sniffs the air. The thing you have to remember about hotwater
 cornbread
is to wait for the burning so you know when to flip it, and then again
when it's crusty and done. Then eat it the way we did, with our fingers,
our feet still tingling from dancing. But remember that sometimes
the burning takes such a long time. And in that time—sometimes—
poems are born.

Poems are born every time I breathe out and those poems have faces that drift into mist, those stories have no names, those stories are people, like my father, who do not exist. But still they inhale and exhale, scream and fuck and giggle and weep and are damned.

Poem For the Man Who Shot My Father

I don't know where you are now,
but for the purposes of this poem
I will imagine you dead
The circumstances of your death, of course,
should be ironic. A bullet smashes into the back
of your skull. A bullet smashes into the back of
your skull. A bullet smashes into the back of your skull. A—
coincidence.

For the purposes of this poem, but only for the purposes of this
 poem,
I will imagine you in hell, a hell where you are doused and torched
each second, every second, and you feel everything, you feel it all.
And for the purposes of this poem, I would like you to describe
my father's face, the moment when he saw you, wild-eyed and thirsty,
The moment when he knew, the moment he turned to run. To run.

And for the purposes of this poem, I would like to hold that picture
in my head. I would like to live over and over and over again

that look of an animal trapped in the headlights, because even
 though
I have imagined you dead,
you are probably not too dead to remember
that there is a hell here too.

I have never seen this man, but I know he exists, my longing for
the story's crazy ever after has invented him, and now—Jesus, stop
her, stop her, for heaven's sake, stop her—I'm going to write him
down and put words into his mouth—*motherfucker, you don't know
me, I will kill you.*

There is a hell here too. And I stroll through slowly, a new visitor wear-
ing my best shoes and all of my new names: The face of American
journalism. Talentless traitor. Imposter. A dark day in the profession.
What affirmative action has wrought. I stroll through hell slowly, my
halo in flames while reps of that inky sacred trust ring me like vultures,
screeching *oh no, oh no, little missy, make yourself at home, we're
sewing your feet to the woodwork, can't hide what you done, it was in
all the papers. You sinned so hard it rocked hell's foundations, why the
devil hisself is scared to come out and make your acquaintance.* And I
wonder what *they're* doing in hell, all these editors and reporters and
copyeditors and layout men and interns and publishers and paper-
boys and they scream *you put us here you put us here, damn
everybody's on the internet nobody reads papers anymore because of*

you and your flights of fucking fancy, now we can only hold our heads up long enough to hold yours down. You are a bad person, you are a bad person, you are a bad person, you are a bad person, we are all obsessed with you, we are all obsessed with you, you are the nigger we invited to dinner and now you just won't leave you just won't leave, you just won't leave and why won't you leave, because we don't intend to let you.

Yes, when I desired an impact that didn't seem possible by ordinary means, I created people and had them say what I wanted to hear, they clung to the sides of the story, gave it its gasp. I played God, not very well, and blurred the line that separated us from the ghosts. Yes, my father is alive and well and sitting at that table over there, sipping his coffee and fingering a neat round hole in his head. Yes, I have come to dinner and I am gobbling your children. I am creeping into their pure impressionable minds, I am fucking them senseless, slitting my wrists and bleeding on their composition books, I am the boogiegirl, crazy as a bedbug, shitting in their alphabet soup, making them question everything they've been taught—

and *you* have taught them everything.

Except this:

How it feels.

The first time, the words flow so smoothly that you really begin to believe that you have created them, and for the sake of the whole, you bend the back of one of those words, you hear its sound and its sound tells you how true it is. Then the music of the sentence, all those splashes of color on that orchestral canvas,

blind you to the wrong in it, you do not hear the insistent voice like nails dragging skin from your back saying *that is not true that is not true that is not true that is not true, that is not true* and the lie sits complete on its own polish and you think oh you silly gods can't you see that the heat surrounding a word tells you how true it is?

But the first time left a twist in my gut, and the second time a knot in
 the throat of me
and by the tenth time that scratchy insistent voice had shriveled to
 a weak whisper
and each whisper was a stroke, damn girl, damn, that's beautiful
and the chorus of strokes grew hypnotic like the loop on a rapper's track
and I *became* the strokes, I became the words, I gave them blood
and blessed the many versions of me with voices that would say
only the perfect things, just what I needed to hear,
just what I decided *you* needed to hear.

Yes, I was a fool—I was God, giddy at the moment of creation, hardly done with a neck, an anklebone, a broad flat nose, before wanting more, more, more of these people-no-people standing behind, in front and on either side of me, spilling out only words that mattered, gorgeous words crafted by me, me who was all of them.

Yea, yea I hear ya.
There she goes again, you're sayin', sneaky poet gal, slicking over
 the surface

of the shit smell with pretty pictures and sleight-hand dazzle, trying
 to poke that flower though concrete.
The issue, Miss Patricia Ann, is the fact that you made up folks who in
 turn made up stuff,
and we aim to know what happened.
Yes. You are here to hear the unraveling and the mending. I am here
 to unravel and to mend.

At 51, my pubic hair is graying, snowy silver tendrils sweat and grow
 tighter under
the threat of love. My name is Patricia, like three downbeats in a line
 of song.

I have grown up too damned fast, know too damned much.
I strolled into hell, through and out of it, leaving my best shoes sewn
 to the woodwork.
And now I am on my knees on every carpet, clawing, chips of
 maroon now colored like rust
collect beneath my fingernails. I am gathering my father's stories.
I retell them, rewrite them, and he dances that stiff-legged old black
 man dance on top of every letter,
he dead-squeals every syllable, he's a stone-stiff growler serenading
 his famous baby girl:

You know you did wrong, baby
When you lied for all to see
Well, you know you messed up baby

When you lied for all to see
But I'll always be sweet daddy
Come here and cling to me

We are bluesman and babygirl, entwined.
My feet are on top of his.
We are dancing in the kitchen.

A wise old man once told me that you can find anything, anyone
in three phone calls. It takes three days to find a gun,
tiny enough to be a toy, black to the point of blue, an oil stink
to the battered metal. Beg for a dollar and folks will leave skid
marks running away from your shame; ask for a weapon and they
will gladly take time out of their busy schedules to guide you to the
 boom.
Don't trust a human being if you can help it.
A man will sell you your own death from the trunk of a compact
 car
hugging the curb of an ordinary boulevard, he will hand you the gun
and his fingers are like teeth, then seeing the dead end
in your eyes asks *You ain't gon' do nothing stupid, is*
you sister? and you suspect he may be the second coming
because he does not wait for an answer. Once it's mine, really mine,
I swagger toward my own destruction, legs suddenly as lazy and
 bowed

as John Wayne's. For five days straight I practice seducing the slick
 barrel,
I close my lips around the gun's hot eye and breathe in hard,
lacking the soul to drag the trigger backwards,
hoping to *suck* the purifying bullet through the chamber and send it
searing through my body to my toes, certain that a complete death
 is the only
cleansing the world will accept. Or perhaps this snuffing out of self
 will just be
a well-timed but gruesome hallelujah,
a tsk-tsk don't ya wish, a touché got her out the way,
a bloody period at the end of a fragment of a sentence:
And then she.
Journalists around the world celebrated as.
Contacted at her home in Chicago, her mother.

Or maybe my body, old friend that it is, will refuse to let loose my
 soul.
I will spend eternity pumping bullets into my head and the wind will
whistle through all those neat, perfect holes
the way it whistles over the bowed heads of flowers in a field.
My penance is that I will keep living to see myself keep dying.
The boom and the backflip. The boom and the backflip.
My obituary perpetually ready, humming in the bowels of newsroom
 computers,
the date of death changing with each fucked up kapow, each perfect
 hole.

Frustrated headline writers abandon all attempts at objectivity,
 write:
Disgraced Ousted Sinful Ex-columnist Just Doesn't Get It.

Accepting of the idea if not the execution, I hide the gun on a book-
 shelf
behind one painfully alphabetized row of poetry volumes:
The One Day by Donald Hall, Old and New Poems by Donald Hall,
The Museum of Clear Ideas by Donald Hall, and To Put the Mouth
 To,
an exquisite and quite hurtful book by someone named Judith Hall,
which contains a poem which contains these lines:

Did I remind you how useful it is to declare
Your writing true? Let your voice break:
The horror, horror, harrowing:
How language cannot contain the wounds…
Your words in the mouths of stars who die,
Bleeding in oval shapes. The actors
Rarely die to make finales realistic.
You should ask if I enacted pain to—write,
Calling myself the victim-witness-priestess
Who knows she dies—is dying
Imperceptibly, her hand warmed by remote
Controls, switching channels. She controls
The news.

The gun bides its time while the phone keeps clanging,
it waits while television newsmen with too many
canine teeth rap on my front door, it lives there behind the rhymes
 while
poets choke the phone line with tears, while salt of the earth is seduced,
it lives there while I celebrate my 43rd birthday, the occasion itself
a glaring mistake. The gun learns to breathe in the darkness, secure
 in its
Donald Hall-way as guests suck hot sauce from their fingers,
armchair quarterbacks in *my* armchair comment on how well I seem
 to be holding up
and backstabbers sharpen their instruments,
mentally price-tag my possessions—including the warm-blooded
 one—
and shake their asses to the strains of my impressive record collec-
 tion.
The gun smells oilier, primes itself,
woos me with an unbelievably funk-filled siren song,
baby bring your baaad ass on up heah,
and the damned thing knows I will climb the stairs to my office,
take it from its place on the shelf and lie on my back with dead sum-
 mer air
drooping outside the shutters, say goodnight gracie, good night gracie,
and the icy unquestioning O of the barrel's end feeds me oxygen,
spits in necessary breath, and oh, in my head I write my ass off,
I invent a me who never existed, I fill her mouth with kickass quotes
instead of bullets, I'm where oh I'm there with tears in my hair,

proud owner of a gun that memorizes lines of poetry
and gets the last laugh by giving life instead of taking life away.

You ain't gon' do nothing stupid, is you, sister?
Yes. I am staying here, upright, unbroken, deserving of this air.

And these are words I can still use.
 Fluent. Funky. Anemone. Android. Penis. Shogun. Sonnet. Chisel.
Shield. Rondolet. Milkshake. Benefactor. Freeze frame. Hummingbird.
Brush. Plethora. Specification. Concussion. Jump. Jostle. Cling.
Trapezoid. Shroud. Japonica. Darkling. Concubine. Associated. Cannibalize. Blather. Socket. Cunnilingus. Flesh. Radial. Ciao. Adios. Au
revoir. Radio frequency.

These are words I can still use.

Mesquite. Stitch. Landscape. Handsprings. Soprano. Shoulder. Thigh.
Plaza. Cancer. Flute. Summer. Fragment. Nut graph. Abundance. Nipple. Opacity. Queer. Serpent. Palate. Javanese. Multipurpose.
Mitsubishi. Touch. Divinity. Inadvertent. Beauty.

These are words I can still use.

 Deception. Crescent. Petal. Candle. Murmur. Apple. Tongue. Refrain.
Firewater. Momentum. Balladeer. Sunlight. Sustain. Boompke. Whiskey.

Skull. Apocalyptic. Bifocal. Syllabus. Fragrant. Again anemone. Gravity. Moonbeam. Gutteral. Modify. Grapes. Animation. Otherwise. Paradox. Apricot. Leopard. Eden. Infant. Momentary. Select. Sleep. Imprinting. Lullaby. Hands. Adultery. Vibrate. History. Privacy. Approach. Witch. Wrinkle. Erasure. Twist. Reprimand. Glory. Blame. Skeleton. Peculiar. Auction. Man. Did. Not. Give. Me. This. Gift. Man. Cannot. Take. It. Away.

Man did not give me this gift.
Man cannot take it away.

Patricia Smith is a poet, spoken word performer, and playwright who spent ten years as a journalist working for papers such as the *Chicago Sun-Times*, and the *Boston Globe*. Lauded by critics as "a testament to the power of words to change lives," she is the author of four acclaimed poetry volumes: *Teahouse of the Almighty* (a 2005 National Poetry Series selection and winner of the 2007 Hurston/Wright Legacy Award in Poetry), *Close to Death*, *Life According to Motown* and *Big Towns, Big Talk*. *Blood Dazzler*, a new book of poems chronicling the devastation wreaked by Hurricane Katrina, will be released by Coffee House Press in 2008. A four-time individual champion on the National Poetry Slam—the most successful slammer in the competition's history—Smith has also been a featured poet on HBO's *Def Poetry Jam* and has performed three one-woman plays, one produced by Nobel Prize winner Derek Walcott.

Total Disaster:
Sketching Sanity

FLY

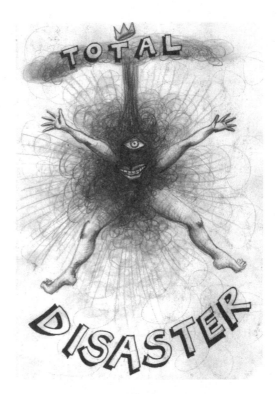

I have been keeping a sketchbook ever since I can remember. I think I'm a born documentarian. When I was growing up, my family moved around a lot, and drawing became one of the stabilizing forces in my life. Since then, drawing and writing have always helped me to focus, relax and situate myself within constantly shifting, sometimes scary but always captivating environments.

I had all the signs of manic behavior from a very early age, but was always upstaged by my more flamboyant family members and friends. When I was in my late twenties, I had a nervous breakdown. I didn't have anyone to help me during that period, so I obsessed

over art projects and my sketchbook, which became my life pre-server. My sketchbook was like a house for my brain. Drawing allowed me to visualize and deal with the extremes of my mood swings.

I started doing self-portraits as a way to get stuff out of my system and on paper, so I wouldn't have it bouncing off the walls of my skull. At the time of my breakdown, I did a whole series of self-portraits I can't even look at anymore. In fact, I destroyed a lot of them. They just freaked me out so much. I still have a few that I keep rolled up. I will not show those sketches to other people because they're just too personal. They are what was really in my brain at that time.

Through the years, I've learned that there's a fine line between what you want people to see and what you need to keep to yourself. Different people have different boundaries for this line. At this point I have three books. I have a public sketchbook that I feel the most comfortable sharing with people. I have a notebook/sketchbook that is more personal than the public one. Finally, I have a dream journal, though I haven't kept it up lately, and that's totally personal. That stays away from everybody.

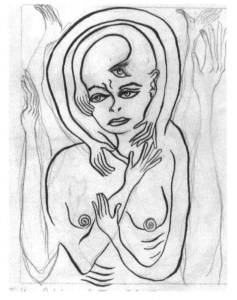

A lot of the drawings I'm showing here are from a time when I felt really disconnected from my head. I was having that disassociation thing happen a lot, where I'd be in the middle of the room talking to somebody, and then suddenly I'd feel like I was on the other side of the room. I'd still be talking to the person, but I could see myself flipping out and not knowing what to say and people looking at me weirdly. I kept thinking that if I could connect with my brain, I could be in my body, but I didn't know how to do it. So I kept trying to draw pictures of it happening. I felt like maybe if I could draw the pictures, they could be my map into actually getting back into my body.

That's the thing about "going nuts," or having a nervous breakdown—you kind of lose sight of yourself. You get sort of confused about where you are in relation to what is considered the "real world," or where you are as a human being in the collective perception of reality. Art journaling helps me by opening up an effective conversation between my conscious and subconscious. In fact, doing self-portraits, sitting down and just looking at myself, helps me situate myself within my perception of the world. It gives me a little bit of an anchor, and is very grounding.

For some people this is not going to work, because for some people, looking in the mirror is frightening. When I had my nervous breakdown, looking at myself in the mirror was extremely frightening. Sometimes I did self-portraits without looking in a mirror. You don't have to actually look at yourself to do one. It doesn't even have to resemble you; it can be something completely abstract. It can be expressing an emotion you're having. That can be a self-portrait.

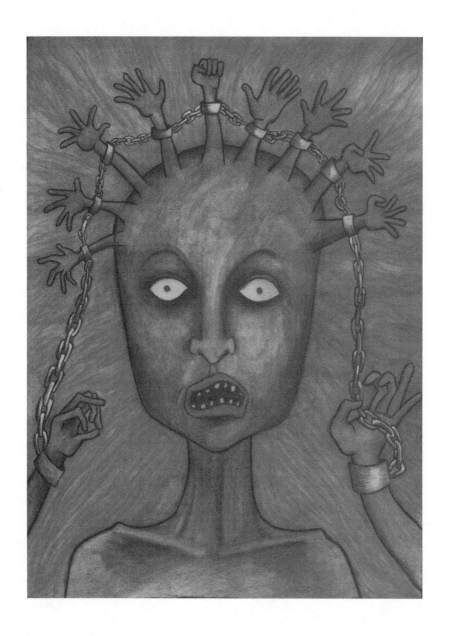

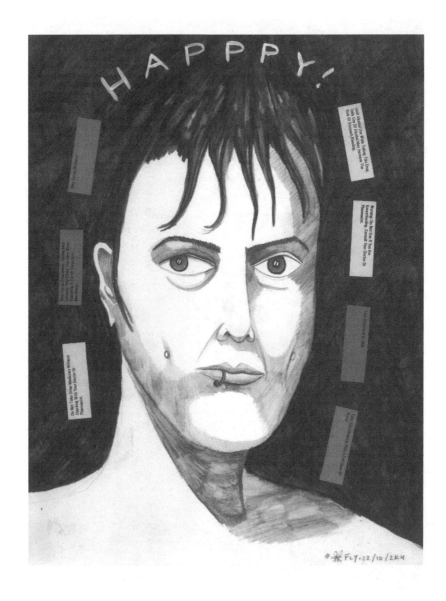

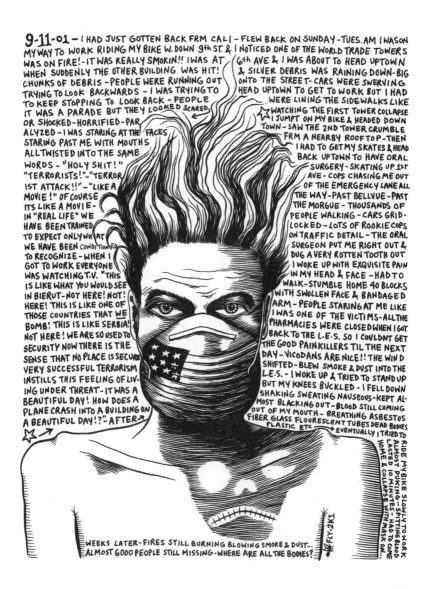

B eing manic-depressive means dealing with extremes. For example, once during college, I went a whole month without sleeping. My brain would not shut off, it just kept going and going. I did these brilliant projects, got high marks, graduated with special honors, the whole deal. But after I graduated, I mentally shut down. Suddenly, all I wanted to do was sleep. When I wasn't sleeping, I went for long runs. I had to be physical because I couldn't do anything creative. All of the ideas were buried underneath this sludge and I was suddenly so uninspired. Then I felt so pathetic. I spent three months that way.

Mania's like a sugar high, but you can't live on sugar. It will destroy your organs, it will destroy your body, and you will die. It's like any kind of high. You can't exist in a state of euphoria forever. You're going to come down and you're going to pay the price. You're going to have to pay the price in your depressive state for every moment you spend in your euphoric state.

Also, at some point you're going to realize that the stuff that you produce in your manic state is not all genius, even if you think it is when it's happening. I've produced a lot of crap in my euphoric state as well as a lot of stuff that I think is really good. You really have to be able to go back and look at what's good with a rational mind and see what's actually working.

I t's taken me awhile to figure out what works for me. I used to be very much against authority and enforced medication. I believed that "crazy people" are actually brilliant and shouldn't be drugged, because it will take away their creativity. I kind of changed my tune after trying to take care of friends who could not function without medication. Much later, there was a point where I was trying a lot of medications and feeling a little bit like an experiment. Meds were supposed to make me happy. But with every medication came all these warning stickers, like there were all these warnings that came with happiness. Finally I got sick of it, and in one portrait, I peeled them off and put them around my head, like a halo.

People's individual imbalances are so varied that it's really important not to just apply one formula to everybody. You can learn things and take suggestions from other people, but you can't just take someone else's routine and expect it to work. A big problem in the whole mental health industry is that they try to apply these formulas to people, but everybody has to figure out what is best for themselves.

People also change at different stages of life. Your environments and physical make-up are constantly changing. Your hormones, my god, your hormones will totally affect you, especially for women. What worked for you last year might not work this year. You have to be constantly reassessing. For me, working in my sketchbooks allows me to do that constantly.

There are a couple of other basic things I've learned to do through the years. Simple things that can make a huge difference. It sounds basic, but drinking lots of water can do amazing things. Sometimes you're all fucked up and it's because you're dehydrated—its so sim-

ple and obvious but it took me years to realize. Regular sleep is also really important. Sometimes it's hard to go to sleep because of the crazy environment you're in. So, creating a situation where you actually can sleep is important. Sometimes exercise can really help with relaxation. Also, when you start exercising, endorphins start flowing and that's going to really help to increase your good mood. Besides keeping a sketchbook and working on comics or illustrations, going for a run is the most calming and grounding thing I can do.

A nother thing I've found to be true is that it's always good to be aware of your surroundings in order to calm yourself. What I like to do if I'm in a situation where I'm starting to get anxious is take a deep breath, take a good look around and pretend I'm memorizing a setting for a drawing. Because if you take a look around, you can sit there and do an exercise where you plot your escape route.

Probably one of the most important things I've learned is that if you're being super creative and everything's super great FOR YOU, well that's great FOR YOU, but how is that affecting other people in your life? If you start really looking at that, then that's going to start affecting you too. So you have to start thinking about how you're going to balance in your life, not just for you personally, but for people that are surrounding you. They are part of your environment, and you want your environment to be healthy, supportive and inspiring, so you really have to look at a bigger picture.

I encourage everyone to keep a sketchbook. Art journaling can really help navigate your crooked path by opening up an effective conversation between your conscious and subconscious. As you gain insight into your cycles and find some balance between the two states, the work you produce will be just as good. It may not come as fast as the art you make while unstable, or make you feel like it's tearing you apart in that way. But it's going to be as good, and maybe even better, because you can mold it as it comes. You can have a say in it instead of simply being a conduit for this flood of stuff that you can hardly control. Since I've been on a more even keel, I'm a lot happier with what I'm producing. It's far more coherent, and I'm able to direct it, instead of having it direct me. That's what I really like about being in control of myself.

Fly has been hanging out on the Lower East Side of Manhattan since the late 80s where she paints and draws comics, illustrations, and sometimes murals. Her work has been featured in the *New York Press*, *Juxtapoz*, *The Comics Journal*, *Village Voice*, *San Francisco Bay Guardian*, *Raygun*, *The Bradleys (Fantagraphics)*, *World War 3 Illustrated*, *Punk*, *Maximumrocknroll*, *MonkeySuit*, *Slug & Lettuce*, and many more. Fly has self-published numerous comics and zines. Her first book *CHRON!IC!RIOTS!PA!SM!* was published in 1998 by Autonomedia. *PEOPs*—a collection of 196 portraits and stories— was published in 2003 by Soft Skull Press. Fly is currently working on many projects including a novel called *Dog Dayz*, a new volume of *PEOPs,* a squatter museum, lots of commix, and soon a new book about the New York activist center ABC No Rio. Visit her at www.bway.net/~fly.

Slash an' Burn

INGA M. MUSCIO

I hurt myself today
To see if I still feel
I focus on the pain
The only thing that's real.

—TRENT REZNOR VIA JOHNNY CASH

Grief is all about who died.

And when, and how.

And how you found out and what was going on in your relationship with the person at the time. Funerals and memorial services are big lies for the people who are not destroyed by a death so they can feel like they have had closure and said goodbye.

I never said goodbye to my dad, my Grammy or my brother. They still affect my perspective every bit as much as my living family and friends. I hold them close in my heart just like when they were alive to talk shit, tell jokes and offer grave warnings on the dangers of not eating meat.

Goodbyes are mostly lies, shut up about goodbye.

Our family's youngest kid, Nick, died when he was just a month shy of sixteen.

I write "Nick" and "died" and they are just words. Unfortunate words—like "great-grandmother" and "slave," or "sexually abused" and "children," or "war" and "commenced." Unfortunate words that mean unfortunate things, but after you read them, you move on to the next progression in the story, eager for the sentences about prevailing and *possibly* veiled justice that will inevitably start taking shape.

Literary, linguistic and grammatical ill directions of this strain are cultural responses. Our culture is terrified of death and in total denial about history, thus creating a supply and demand for happily (or heroically prevailing) ever afterness. And it is our denial/fear of history and death begetting the great violence we have all come to know so well.

In my case, this violence would be self-inflicted.

Unfortunate words of this cultural strain are properly considered if, after reading them, you go directly into the past, which you will traverse for a while, and eventually—after covering anywhere from 2,000 to a few years (depending on the nature of the unfortunate words)—you will come back into the present, where you shall remain, and the story has no end until all of the protagonists and antagonists and all of their progeny and everyone who remembers them are dead.

The end is a lie.

It hardly ever happens.

As a writer who has labored endlessly over the ends, only to see

my words take on lives of their own, nourished by the endless perspectives of readers, I am qualified to say that the end is a lie, just like goodbye.

Forget the end.

Nick was born and he was nice.

This stood out in our family because I wasn't terribly nice and neither was my sister Liz and neither was our older brother, Joe B. We all had nice qualities, but none of us were really nice kids.

We liked to raise hell.

Nick was nice though, and his way of negotiating the terrain of his siblings and parents was to roll with all of us, individually and nicely.

Nick was one of those self-sustaining types. He could entertain himself for hours and hours. I used to lie on the floor and listen to complex storylines going down between his army men, a giraffe and three matchbox cars, or the cat's flicking tail and some mutant ninja turtles. He was so deep into what was transpiring in the corner he'd settled himself into, any interested passerby was free to listen in. If you had to interrupt him to tell him dinner was ready, he'd hear you and hop up out of that world and into this one, but if you just stood there, he either ignored you or honestly did not perceive you. It was a good survival tactic—one he started employing as an infant.

Nick was smart.

There was no reason to harbor ill will against him. At least, not for long. He was a prank-puller and did stir shit up, but his jokes came from a kind-hearted place. Joe B., Liz and I had ongoing and historically entrenched vendettas, not unlike Bosnia, Serbia and Croatia.

Nick was our Switzerland.

He was the only person in the family who offered peace and laughter on a guaranteed basis.

I adored him.

Our dad died when I was almost thirteen. My parents had divorced when I was eleven, but our dad just got a camper and stayed at our house when he wasn't smuggling drugs from Mexico, or caught up in a poker marathon at the Horse Shoe Club. This did, however, give our mom the space for a discrete relationship with a woman named Karen. During that time, I figured they were friends, but I know I suspected something more because this one time I was taking a bath and talking to my dad and I said, "Dad, is mom a lesbian?" And his answer resonated so deeply, I knew I would remember it all my life. He heaved a big sigh and said, "Inga you may not understand this now. Karen is a lesbian, but your mother is not."

I understood then just as good as I understand now.

When our dad died, Karen came on the scene in full-force. At first, it was having dinner at her condo and she played Joan Baez and I liked her well enough. After a year or so, she started taking Liz and Nick every day after school, only bringing them home when our mom got back from work—usually after midnight.

When I voiced my profound unhappiness about this new "family" routine, Karen's controlling nature emerged. Karen was raised under children-should-be-seen-and-not-heard roofbeams. I, on the other hand, had been encouraged to speak my mind. It appeared that, to Karen at

least, if I was not going to go along with her idea of what a family should look like then I should not be a part of the family any longer.

Things turned really bad when she started shit-talking our dead dad. There were *ample* reasons to shit-talk our dad. Grammy and Aunt Genie freely shit-talked the motherfuck out of him, but it was not Karen's place. I started to throw fits whenever she'd come to take Liz and Nick. I called the police and reported her kidnapping my siblings. Finally, one day she said something shitty about our dad and I slapped her across the face. This inspired a campaign to assassinate my character within my family and among her family and friends. Now see, our dad was an asshole. I knew how to argue his sorry ass into the ground. I did not know how to deal with someone who poisoned other people against me.

Dad was dead, my family, splintered.

Joe B., our older brother, was off being a teenager in the world of his girlfriend, surfing, shady economic transactions and more or less going to school. Meanwhile, Mom, Liz, Nick and Karen were becoming a family and I could be a part of it if I *wanted* to, but why the fuck would I want to be around Karen? Karen's idea of a family did not include someone like me, and my idea of a family certainly did not include someone like her, but it was *my* fucken family that she jacked. Every word out of her mouth that was directed to or about me was negative. Liz and Nick started hating me. I became a punk rocker and got into serious trouble all the time, feeding seamlessly into Karen's narrative.

For her part, our mom was all swept up in this new, not so obviously abusive relationship. On the face of things, it certainly seemed

a grand improvement from her husband. Karen came off as a really nice person. It took a long time, and a great deal of proximity, to see that she was a highly passive aggressive pathological liar, secret alcoholic and closeted self-hating, small town homo. Like our dad, she was not necessarily mean-spirited, but in her underhandedness, she was much more quietly violent and controlling. Unwilling to come out with their relationship, my mom found herself trapped in a big fat, sprawling Jabba-the-Hutt of a lie.

Essentially, my mom's a badass. It took her a while, but she kicked the fool to the curb. But not before my brother and sister became virtual strangers to me.

When Liz got into adolescence, she realized that the whole being-seen-and-not-heard thing meant you had no right to rather normal things, like opinions and beliefs. One day when me and my friends cornered a kid who was giving Liz a hard time, she figured maybe Karen didn't have her story straight. She and I started spending more time together and rediscovered one another. Nick, however, was still too young to question Karen's poison about who I was.

I eventually more or less graduated from high school, and moved away.

Went to Seattle.

In this time, I made compilation tapes for Nick, reaching out to him for the first time in so long. I missed him badly and saw that he too was having some of the same power struggles with Karen as he moved away from childhood.

He, Liz and Joe B. went to Oregon one summer to visit our

Grammy and relatives, and I drove down from Seattle. It was a memorable trip because Nick was my friend, my brother, again. We had a wonderful time, swimming, laughing. I came back home feeling a sense of peace that I had not felt in almost ten years. I had my family again. Packed up my stuff that fall and moved to Olympia to go to Evergreen—the no-tests, no-grades college I'd been accepted into.

And so it was that following April I got a phone message from my mom when I came home from work one day. Her voice was tinny and shrill, saying unfortunate words: "car accident" and "brain scan" and "call me, call me here, I am here at the hospital."

Losing Nick was bad the first time.

It was incredibly painful to witness my beloved brother distancing himself from me, at the behest of someone who in no way had my interests anywhere near her heart. Nick and I lived in the same house for almost ten years without ever again enjoying that dearly close bond we once shared. That was very bad and devastating. I grieved for the loss of my siblings for many years while we lived under the same roof. When Liz became my sister again, I figured it was just a matter of time before Nick became my brother again too. And lo, that came to pass, and the loss was ebbing quickly, and then, like a tsunami sucking away the whole shore before it comes barreling ass inland, he was gone.

I would never see the man this joyous child would become. Never play with his kids. Never feel the warm breadth of his hand covering mine.

That is the only goodbye, that is the only end.

Goodbye, the end to the future of Nick.

I was still in my first year at Evergreen for a degree in writing. I had been writing since I was seven or so. The morning I woke up in Olympia after seeing to all the memorial crap, I knew only one thing: write or die. "Die" did not necessarily mean killing myself. I could not do that to my mom and brother and sister. "Die" meant leaving who I was and never coming back again. I saw the option of that, and it was easy and attractive on many levels. It could involve heroin, insanity or full court press emotional retreat.

Probably heroin.

But I knew writing better and had already established a pretty serious trust there. Writing had a proven track record saving my ass, so I consciously chose writing over any of the easy, attractive deaths that waltzed around my imagination.

I wrote with survival urgency.

Every morning I'd wake up and write for hours before going to school. I did my schoolwork and wrote. I drank coffee and wrote and did school work. That was all I did. I could not eat. I could not socialize on any level. I could not sleep. This is when I developed the habit of reading until the book falls out of my hand and quickly turning off the light. If I was fast enough, I would fall asleep without remembering Nick was dead. If I remembered, I had to turn on the light again and read until the book fell out of my hand. To this day, I cannot fall asleep any other way, and must have a reading lamp within hands-reach of my bed.

I went to a naturopath and she told me exactly how much protein I needed to sustain my life. I forced myself to eat protein bars. It took at least an hour of concerted effort to chew and swallow an entire bar. My throat was full of loss and food did not pass easily.

This was my life for a year or so. Maybe more.

And eventually I wondered if I would ever feel like living again, if I would ever even begin to heal from the pain of this loss. I mean, it had been well over a year, maybe pushing the two year mark and my heart was still destroyed and I could not maintain eye contact with anyone who did not know my brother, which meant almost everyone in my daily life. And so, maybe I would never heal. Maybe I would be like this for the rest of my life.

Maybe heroin wasn't such a bad idea after all.

And that was when, while washing dishes, I broke a glass in the sink and cut my hand quite deeply. I did not feel it, just noticed that the dishwater was pink. I held my hand up and blood poured down my arm. I could see my heartbeat and pulse in the flowing blood. My mind raced, making connections, seeing possibilities. I bandaged up my hand when I probably should have gotten stitches.

I got very good at bandaging.

And the thing of it was, I felt no pain from this cut, and became obsessed with watching it heal. I kept it clean and monitored its progress from a bad wound to a surly scab, to a tender new scar. By the time it was healed up, there was a two-week old slash on my inner-calf and a brand new one on my forearm. I'd broken a bunch of glasses and kept them in a vase in the refrigerator. Cold glass seemed clean to me. I slashed my arms and wore long-sleeved shirts. I slashed my legs and hid them in pants, stockings or knee-high socks. I never had more than three cuts in various stages of healing, but I cut deep. So deep that now I look at the scars all over my body and wonder how I managed to avoid opening an artery or major vein.

I discovered burning myself while lighting a stick of incense in this new mindset. Burns occurred with more frequency, and my chest, stomach and the insides of my wrists were always dotted with wounds. These too were sometimes deep, but not as deep as the cuts. The sting of pain felt good. It was such a luxury to identify and know a pain.

And so this was my life for a time.

My cut up body was a secret, sacred garden of grief. It kept me alive and filled with a kind of wonder. I needed desperately to see that I could heal, and so I slashed and burned and watched myself heal.

I really don't recall how I stopped. I slashed and burned for a little over a year and then I just didn't do it anymore. Perhaps I saw that I had healed enough times, and figured I could do this on my own and did not need a garden of grief anymore.

I do remember that around the time I stopped, I had something like an inner-body experience while riding the bus one afternoon. It lumbered around a corner by the waterfront and all of a sudden, I was standing inside my heart and it looked like a scene out of *Apocalypse Now*. Agent Orange Was Here kinda thing. And I immediately thought it was a rare opportunity for a person to fully re-landscape their own heart, and lord, I could seriously plant some new stuff in here. And then I was on the bus again.

Maybe that vision re-focused the energy around slashing and burning, because stopping was natural, easy and, evidently, unmemorable.

I have read a lot about cutters—psychological assessments and whatnot—and none of it ever resonates with my experience. When

my brother died, I projectile-vomited screams, but it was not acceptable for me to do that every day for a couple years. There was no space to grieve, so I found a quiet way in a very personal space. Maybe it would have been, I dunno, *healthier,* to connect with a tattoo artist and get one thousand white cranes etched into my skin. But I was twenty-four and keeping broken glass in the fridge to slice myself up every week or so seemed like a perfectly acceptable recourse.

I don't really like to write about this subject because I am supposed to have the moral responsibility to offer a cautionary tale, and I can't do that. The slash an' burn time of my life served me well, though it was costly. I have bad scars on my body that bring stares and questions when people notice them. I have meltdowns if someone touches them. I am reminded of what, exactly, my grief looks like every time I take a bath. It is, however, a fair emotional market price. The alternatives would have taken me down a bad road that I would never have retraced.

Sometimes, unfortunate words happen in the sentences of your life and keeping the pain they bring trapped inside your body is just an incredibly bad idea. Sometimes, even when you are absolutely consciously blessed with a constructive, creative outlet that has pulled you through many difficulties, the pain that comes with unfortunate words is bigger, stronger, faster and badder than you could ever be. When you are swept up by powerful unfortunate words like "war," "poverty," "violence," "trauma," or "death," you are just a puny human being inside a tornado. There is no possible way to deflect the devastation.

Sometimes, you just gotta go with it and hope it spits you out at some point.

Most always, healing is not a destination or an objective. Healing is a daily thought process, a series of infinite questions and choices, a skill that is not taught, much less revered, in our culture.

That is how I see it.

And it still sucks ass that Nick is gone.

The end.

Inga M. Muscio is the author of *Cunt: A Declaration of Independence* and *Autobiography of a Blue-Eyed Devil*. She does a lot of public speaking, and lives in the Pacific Northwest.

SHE'S LOST CONTROL AGAIN
(Or How Alice Learned to Drive)

NICOLE BLACKMAN

Holy

I eat only sleep and air
and everyone thinks I'm dumb
but I'm smart because I've figured it out.

I am slimmer than you are
and I am burning my skin off little by little
until I reach bone and self
until I get to where I am essential
until I get to where I am.

Food doesn't tempt me anymore
because I am so full of energy and sense
I can even pass by water now
because I am living off the parts of me
that I don't need anymore.

I could feel the slow drips of pain before
swirling inside where my lungs should have been
Now I'm clean inside.

I threw out hundreds of things that I didn't need anymore.
All my dresses and bras
stupid things like jeans and socks.

Most days I float through the house naked
so I can see myself in the mirrors.
I have hundreds of them everywhere
and they talk back to me all the time.
They keep me true and pure.
They make sure I'm still here.

When I knew what I had to do
I took all my notebooks, all my manuscripts
and ate them page by page
so I could take my words with me.

I can finally control my life
and even death
and I will die slowly like steam escaping from a pipe.

This is my greatest performance
and all of the actresses who won my parts will say
how wonderful to let yourself go that mad
how wonderful to go on this kind of journey
and not care if you come back to tell the story.

I scratch words on the walls now
so people will visit this museum and know
how someone like me ends up like this
(they'll say there is art in here somewhere).

Everything that comes out of me is sacred
every tear, every cough, every piss.
Everything that comes off of me is sacred
every fingernail, every eyelash, every hair.

Starvation is sacred and I scratch my bones
against the windows at night.
I light candles and feel myself evaporate.
This body is a little church, a little temple.
You can't see me now because I've gone inside.

My family doesn't call anymore.
My friends don't call anymore.
You can't hurt me anymore.
Only I can.

And that's okay.
I don't need them anymore.
I can live off of me.
I speak to me.
I dance with me.
I eat me.

When they find me, I'll have a little smile on my face
and they'll wrap me in a white cloth and lay me in the ground
and say they don't understand.
But I do.

I don't hurt anymore.
I'm not lonely anymore.
I'm not sad I'm not pretty anymore.
I made it through.

I feel so holy and clean when I stretch out on the floor and sing.
Sometimes god comes in for a minute and says I'm doing fine
I'm almost there.

Every day I get a little closer to vanishing.
Some days I can't stand up because the room moves under my feet
and I smile because I'm almost there
I'm almost an angel.

One day when I am thin enough
I'll go outside
fluttering my hands so I can fly
and I will be so slight that I will pass through all of you
silently
like wind.

—Nicole Blackman

"Holy" originally appeared in *Blood Sugar* by Nicole Blackman and is reprinted under agreement with Akashic Books (www.akashicbooks.com).

✧ ✧ ✧

Everything comes down to control.

The desire to have it. The desire to lose it. The desire to exert it over someone or something. As a writer, I enjoy playing the puppeteer and manipulating characters to extremes, often far beyond the stages of their real-life inspirations. But I wasn't prepared for how my work would be so totally *out* of my control once it was published, or how much of my most ardent fans' lives would be centered around the issue of control.

Writing always came from a desire to understand things that haunted me, a way to come to terms with issues that made me wonder. Although I never had an eating disorder, with "Holy" I wanted to know what made young girls starve themselves, what gave them a feeling of transcendent powers, what made them think they were at their best when they weighed the least.

When I first performed "Holy," I was stunned at the intense response from young women in the audience, who felt it illuminated something of the complex struggle of anorexia and eating disorders—the way the brain knows it's wrong, but the body succumbs to the joy and the power of mastery. One night, a few audience members approached me to discuss the poem. "I didn't realize that happened to you too…" "How are you doing now, do you need to talk to someone?" I quickly explained it was fiction, a character study. I thought they'd appreciate the fact that I'd written with empathy on a topic often ignored. Nothing prepared me for the narrowing of their eyes when they thought they'd been duped. "So that was all

a lie?" "You think this is a game?" They felt ripped off, furious I'd somehow exploited them.

Eventually I learned not to talk about whether any of my work was fact or fiction, but to respond by asking: "Well, what did *you* get out of it?" or "What did it make *you* think of?" I quickly realized that their questions were really just a portal for them to talk about their own lives and experiences—a way to share stories with a stranger who somehow seemed to know their secrets.

As young women approached me one by one, "Holy" began to take on a life of its own. Fans started using lines from the poem as their e-mail signatures and on their on-line profiles. When quotes began appearing on the pro-anorexia websites that seemed to mushroom quickly in the dark safety of the internet, I was disturbed. The girl from "Holy" was becoming a kind of warped heroine, a patron saint, for anorexics. While most writers dream of having readers become devoted fans, I felt mine were dangerously misinterpreting my work. They were reading the poem as a sacred text on how to achieve their subconscious goal: controlled self-destruction.

They wrote letters, they wrote emails. They sent poems, photographs, drawings, jewelry, makeup, books, stuffed animals, music, crafts and candy. They told me about themselves, their families, their friends, their romances, their schools, their jobs, their towns, their bodies, their self-loathing, and often their history of abuse. They confessed how long they'd been dieting, taking laxatives, throwing up, starving, cutting, lying, hiding, running, burning, hurting and dying.

A few pushed the boundaries, trying to see if I really cared or was just full of shit like all the other adults in their lives. They described

their lives in exhausting detail, daring me to flinch: how much alcohol they stashed in their junior high lockers to get through the day, and the senior guys they blew to get it. Lists of illegal drugs they'd done and of prescription drugs they were on now. Excruciating details about sharpening innocent household implements never intended to cut young flesh. What music was playing when they were gang-raped by their brother's friends.

While the correspondence was overwhelmingly female, occasionally young men wrote to me. Sometimes, a few bruised boys came up after a reading or performance and spoke to me about their struggles with depression or coming out, or they asked how to help a friend or girlfriend who was coping with abuse or self-injury. As I listened to them, I started seeing patterns in how male anger often tended to focus outward—Fuck *you*—while female anger often seemed to focus inward—Fuck *me*.

The equation stunned me. How did this happen and why? Was the impulse innate or socially conditioned? Did the disparity set up women to be more vulnerable to abuse later? The questions circled in my head like hawks. Meanwhile, the girls continued to contact me, and their needs and pleas were relentless.

I wasn't prepared for the hundreds of emails and letters asking for advice, support, insight, or just a message back. These young women were total strangers, what did they expect of me? What happened if I disappointed them? What if they killed themselves because I didn't give them the right advice, or worse, didn't give them any help at all? But their heartbreaking stories just kept crawling out of my computer.

I wrote everyone back. Everyone. Whether I was the best-quali-

fied person to advise them was irrelevant now. For whatever reason, I was the one they chose, and in some cases, I was the only one they had. Sometimes I felt like a friend, other times like a big sister. Sometimes I felt like a lighthouse flashing, "Warning, go no further!"

I told them self-destruction is the result of women not knowing how to reign in their power. Eating disorders, cutting, drugs, and alcohol are just some of the strange and violent ways it manifests itself, emerging in a bizarre displacement of power. The desire to self-injure might take on different forms (shoplifting, drunk driving, anonymous sex, running away), but the roots and results are often similar, regardless of the weapon. Over and over, they wrote back, "I don't know what I want, Nicole. I just want something *else...*"

Something. Anything.

I realized that after they'd confessed and unburdened themselves to me, they desperately wanted me to tell them what to do, to give them some kind of traumatized life map. So I started simple. I told them to write things down; that if the dark messages playing on an endless loop in their heads were finally down on paper, it might feel like putting down a giant weight. Maybe then they'd be able to catch their breath, or just sleep through the night. "It's like training a puppy, just put your shit on the paper," I quipped, "and tell me what happens." It seemed to help.

Meanwhile, it felt like I was dancing around the white elephant in the room no one talked about: *I don't want you to die.* But at fourteen, who thinks they're going to die? Not these girls. Not unless they *wanted* to die, and most of them seemed to be just balancing on the edge. I tried to understand why they worked so hard to destroy instead of create,

but eventually I realized they were calling on the (inverted) creative power of destruction, even if it was self-destruction.

I recognized the need for ritual and belief, and the need for mastery at a time when they feel most powerless. For most adolescent and teenage girls, the years of passage are littered with landmines, few more dangerous than the ones found buried deep in their own bodies. They have little control over expectations, school, schedules, family life, their neighborhood . . . sometimes even what they wear every day. The one thing they can control is what they eat, and the starvation and self-abuse often become a twisted kind of secret respite, a determined flag planted in their psyche that says: "*I run this body, motherfucker.*"

After a few years of correspondence, I was drawn deeply into the world of female self-destruction. I saw how combinations of anorexia, bulimia, cutting, burning, drugs, alcohol, and hypersexuality often created toxic cocktails for women. I never pretended to be a therapist, but I started to see patterns in behavior and coping, and hundreds of e-mails later I knew more than most.

The roar of emails quieted a bit, and I was left wondering about some of the girls who wrote to me over the years: were they happy, were they healthy, had they survived? There was no way to know, and I wondered if I'd given them good advice or been any help at all.

And then Alice* wrote to me.

To a psychologist, Alice might be considered an intriguing case study, a "perfect storm" of severe and complex problems. But to me, she was a high school girl in desperate pain with no way out, and

* Not her real name

over the next two years, my relationship with her drew on everything I'd learned about female self-destruction.

She wrote about being molested for years by her father's best friend and sadistically tortured by one of his friends, about her best friend who was abused and then committed suicide, and about the boyfriend she loved who died in a car crash a few months after they broke up. Alice told me about going in and out of the hospital, being bounced between therapists, summoning the courage to report her abusers, and coping with a father who didn't believe her and a mother too far away to help her.

Alice wrote about the scars, both physical and emotional. She described lingering over photos of herself at her thinnest, and wrestling with the impulse to starve and cut herself. She told me how easy it was for her "to get sucked back into the world of calorie counting and excessive exercise. Logically I know what hell it was to be seventy-two pounds. Emotionally? I miss it what it provided."

Like so many of the girls who wrote to me, Alice was trapped in the duality of simultaneously spiraling out of control and wanting to be healthy. She hated feeling trapped by the trauma, but didn't know what options she had. In one shocking moment of clarity she wrote: "I cannot afford to stay the same."

She needed to change. She needed something. Anything.

She wrote that she longed "to be that thin again. Though it's not about being thin . . . I think weight is just a way to measure your control." Her realization made me gasp. I wondered if she realized how perceptive she was, that she was having breakthroughs one after

another, and that even if she'd never be completely over the struggle, she was on her way to being able to manage it.

Sometimes a few weeks would go by without an email from her, sometimes she'd email me a few times a day pleading with me to call her, and it was difficult to explain why I wasn't comfortable with that. My then-boyfriend didn't understand why I was spending so much time and effort on a girl I didn't know, and I wasn't sure how to explain it. How could I tell him: *"Because while I've never done it, I can see why cutting is a relief. Because when everything is so uncertain, there is cold comfort in the reliability of the numbers on the scale. Because I understand it all better than you think. Because I'm no different. Because she is me. Because they all are."*

In the end, I stopped trying to explain it to him, and spoke directly to her.

Nicole: You are HERE and you need/want to get THERE, right? Well, you're laying a path to get there. Lay down a brick or stone in that direction. Just one. You don't have to do it all in one session, and you can't anyway, so don't set yourself up for disappointment. Think for a moment, what could be your next stone?

Alice: I don't know.

Nicole: How about the interview for that volunteer job? That's a stone.

Alice: Okay.

Nicole: What might come after that one? You could write down

how your interview went and how it made you feel afterward. You could meditate before your next therapy session so you feel a little calmer, or you could bring in notes of what you'd like to be able to talk about.

Alice: Good! Good!

Nicole: You can put away those old pictures of yourself and put them in a box and put them far away so you're not tempted to look at them and they won't be a setback. You don't have to throw them away, but you should let the ghosts know you're running the show, not them. What would it be like not to have those images around you all the time. Wouldn't it be just a tiny relief? A small vacation?

Alice: I'll take anything. No matter how small. You've even got me mulling over flushing my diet pills.

Nicole: Think of it this way: the automatic "buy gauze, I might cut myself later" impulse you had in the drugstore, and the "flush my diet pills" response are two very different gears. Do you feel how different they are? Which one feels like you're being driven and which one feels like YOU'RE driving?

Alice: Buy gauze = driven
 Flush diet pills = driving

Nicole: And putting those photos away?

Alice: Driving

Nicole: Interviewing to volunteer?

Alice: Driving

Nicole: Meditating or taking notes for your therapy sessions?

Alice: Driving

Nicole: Making a tomato sandwich, eating it slowly, tasting the summer in your mouth and enjoying the experience of taking care of yourself?

Alice: DRIVING!!

And as I saw her answer on the screen I whispered: *Drive, Alice. Drive.*

Nicole Blackman spent a lot of time alone as a kid. She still does. Her debut collection *Blood Sugar* (Akashic) got much more attention than she expected and she is working on her next one, *Painkiller.* She is a writer/performer whose work appears in *Aloud: Voices From The Nuyorican Poets Cafe, Poetry Nation, Verses That Hurt, Brooklyn Noir* and over 20 albums, including collaborations with The Golden Palominos, Bill Laswell, KMFDM, Recoil, Firewater, Scanner, and Space Needle. She performs internationally and her major live works include *Bloodwork, The Courtesan Tales* and *Beloved.* Her website is nicole-blackman.com and she thanks Amy Lewis and Sabrina for their support on this essay.

Double Trouble in the Love Art Lab: Our Breast Cancer Experiments

ELIZABETH STEPHENS AND ANNIE SPRINKLE

We fell head over high-heels in love during our first kiss in July 2003. Soon after, we began the Love Art Laboratory—a collaborative project dedicated to making art that explores, generates, and celebrates love. The project was planned to last seven years. We hoped that the practice of exhibiting love could be a powerful antidote to the violence and hatred in the world and would engender hope and healing.

We were in our first year of the project, and things were going spectacularly well when Annie found a lump in her rather famous breast and was diagnosed with breast cancer. Breast cancer?! There was no warning that anything like it was coming. Annie had always been so healthy. Now her body was self-destructing; cells acting up, deforming and multiplying out of control, and becoming life threatening. Cancer treatments were going to be challenging. Was this

going to ruin our well laid plans? Was this the end, a new beginning, or both? How would we each handle what lay ahead? Chemo, radiation, no hair, oh my! Oh shit!? How were we going to survive this? We decided to take on Annie's breast cancer, together, as one of our Love Art Laboratory projects.

Exposed: Experiments in Love, Sex, Death, and Art

ANNIE: These are my breasts. How many of you have seen them before? Be honest, and proud. They're quite famous! Did you see them in one of the approximately two hundred porn movies they've starred in? They've been seen in virtually every pin-up magazine there is. I made money with these breasts. Twenty years in prostitution. Lots of guys picked me because of my breasts. They are performance artists. Bosom ballet, bosom tap dance. In Berlin, I did a bosom samba in with a thirty-five-piece samba band on a football field at half time in a clown outfit. Tit prints. Birthday parties; tittie tortes. A doily, frosting, sprinkles and candles. Yep, these breasts have entertained, and brought pleasure to, thousands.

Especially to me. I love my breasts.

Edited still from *Breast Cancer Ballet.*

During cancer treatments we worked with theater directors Neon Weiss and Sheila Malone, and put together a two-woman performance piece called *Exposed: Experiments in Love, Sex, Death and Art.* We made use of any suffering by funneling it into our rehearsals. It's our love story, and it includes scenes about our breast cancer.

BETH

Is she going to die?

I feel like the wind has been knocked out of me.

I have to be strong.

I can't stop crying.

I just feel so helpless.

Why couldn't it be me?

Why is this happening to us just when everything was so great?

What doctor should we go with?

ANNIE

Is she going to leave me?

I feel like my cells are dying.

My nerve endings are frying.

These hot flashes are intense.

Did I do something to make myself sick?

Am I going to die?

My eyelashes are gone.

BOTH

What happened to my libido?

I'm so tired all the time

I don't feel like myself.

All I want to do is watch TV.

Who am I now?

Text from the theater piece *Exposed: Experiments in Life, Sex, Death, and Art*

BETH: When Annie found out that her tumor was malignant, it was a great shock to me and a lot to digest. At that time, I was commuting between San Francisco and Santa Cruz, which was about an hour and a half drive each way to work. It's this really beautiful drive right along the ocean on route one. I did a lot of my processing on that drive. Sometimes I would just drive home to San Francisco crying, or I would stop by the beach for a cry by the water. I showed my feelings to Annie, but I also felt that I had to be very strong for her. So I kept some of my grief private because once you're diagnosed with cancer, there's just this huge medical labyrinth that you enter. It's confusing, there are different parts of the system that don't necessarily talk to each other so that you have to get that information and coordinate it. I didn't have a huge amount of extra time to spend in my own grief.

At the same time my best friend, filmmaker Diane Bonder, was dying of pancreatic cancer. I'd go to chemo with Annie in San Francisco, then I'd fly to New York and go to chemo there with Diane. I was in a lot of grief.

ANNIE: When the doctor said it was cancer I was surprised. My first concern was, "Is Beth going to leave me?" My relationship with Beth is my greatest accomplishment in life. If I were going to die, the hardest part would have to be leaving Beth. We were still deep in the honeymoon phase even after three years of living together. Chemo would put me into menopause, and would probably zap my libido. Many relationships don't survive cancer . . .

My second thought was gee, if I had to get a disease, I was glad it was breast cancer, because it fit nicely into my previous body of work. I had been doing work with and about my breasts for years, first in the sex industry, then later in a more formal art context, like with my tit prints, and my Bosom Ballet performances. Plus as a political activist, I could get involved in some of the feminist politics of breast cancer from a place of experience.

Surgery Performance

Beth asked the anesthesiologist to document the lumpectomy surgery with our camera. He took some lovely, very gory photos. It's always good to find an anesthesiologist with a good eye.

BETH: Sickness is a very abstract thing because most people never see images of the actual tumors. They know that the person goes into the hospital room, and they know that when the person comes out, they're drugged up. People never see what an actual operation is. You only see the stuff after it's been sanitized. I was very interested to see the raw process. What was it really like going into Annie's body? People had seen her cervix during the period of time when she was performing her famous piece, "A Public Cervix Announcement" which is a very different thing because it is art, not an operation. This was a very different view of the inside of the female body. I was curious. I was horrified. It lent an air of reality to the whole thing that I needed to see to fully realize the magnitude of what was going on. Illness is a part of life. Since we'd chosen to make art out of life, and had the opportunity to actually photograph the physical process of the surgery, why not take it and use it?

The Chemo Fashion Show

We dressed up and took photos at all eight chemotherapy infusion sessions, one session every two weeks for four months. Our art-making created some chaos in the doctor's office, but it also brought many smiles to the other ladies getting chemo and to our medical team.

ANNIE: The chemotherapy room was kind of like a beauty parlor, with several ladies sitting around in big upholstered chairs chatting. Our doctor was darling and wonderful, so his chemo room was very lovely and had nice feng shui. Still, I had to sit there for four hours with a catheter needle in my hand while the pharmacology was dripping into me. It was pretty uncomfortable.

Our chemo fashions photo series allowed me to be more focused on what we were going to wear next, and how we were going to take the photos, than on how much it was going to hurt. We felt like we were making something constructive out of something destructive.

BETH: Going to chemotherapy with Annie was a very strange experience because there were always several women getting treatments and I felt that I shouldn't really be there. I also compared it to a beauty parlor until I went to chemo with Diane. Her chemotherapy took place in a small dark examination room. Diane's doctor mixed the chemo chemicals two feet away from us, and administered the chemo right there in his office. Later, Diane did chemo at a hospital in Brooklyn, which treated a whole lot of patients at once. I realized then what a special place it was that Annie was getting her treatment in.

Go chemo-sabe, go!!

Globalization is the year's latest fashion.

A true pimp always escorts his 'ho to chemo!

Chemo cocktails, anyone?

Hairotica

We decided to shave Annie's head when her long, Leo mane started falling out. We asked photographer and friend David Steinberg to document us doing a head shaving ritual. David's eager camera made something that could be very sanitary into something sexy. Our motto is "eroticize everything."

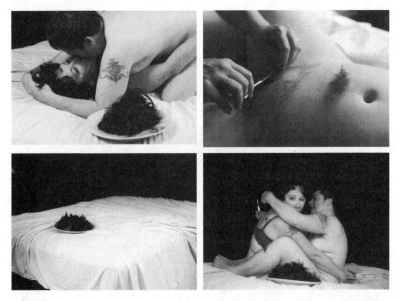

ANNIE: We submitted the photos to *On Our Backs* magazine, a lesbian sex magazine, thereby creating a new genre of erotic photography we coined "cancer erotica." My feeling was that it could be interesting to a.) reveal vulnerability during lovemaking, and b.) to show ourselves having hot sex during a health crisis.

Death can be erotic, because there's a lot of energy around it—lots of emotions and hearts cracking open. Besides, I had documented my sex life for

over thirty years, and why stop now? I think it's a positive thing to depict human sexuality in all its forms—to show older women, round women, and women in chemotherapy.

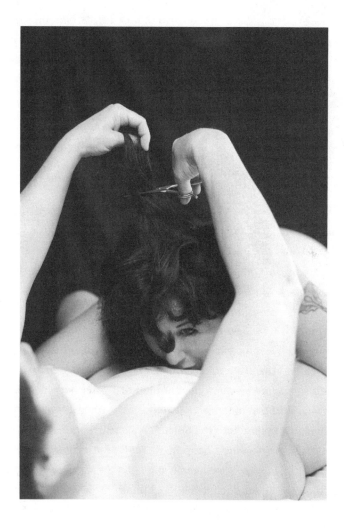

Love Infusion

When our local Community Center asked its neighbors to have garage sales to raise money for its benefit, we rolled up our sleeves. Inspired by the chemotherapy room at our doctor's office, we created a Love Infusion Center. For a donation, garage sale shoppers could sit on a red couch and get a "love infusion." Artist Tina Takemoto assisted us as "Nurse Ana Phylaxis."

ANNIE: We wanted to share the sweet part of the chemo room experience with other people. So we created a painless and needle free infusion room in our garage. In our Love Infusion room, I became the 'doctor' for a change. It helped me frame the chemo as a positive healing thing, and not a poisoning of my whole body, which is what it felt like.

BETH: It almost felt like if we made art out of the cancer, it was going to keep Annie alive, which was a complete case of magical thinking. But art was not keeping my friend Diane alive at all. Diane also documented her battle with cancer, and she painted a very different picture. As her body deteriorated, she made images of that deterioration, to the point where she'd photograph herself having shit blood into the toilet. It was heartbreaking, real, and so courageous of her to document her process, and these images were shown at her memorial. So, in some ways, Annie and I had the luxury of being a little more lighthearted in our documentation. I think we were able to believe in this magical thinking because we had a very good chance of surviving.

Bald Love

The doctor tells us that Annie's chance of breast cancer recurrence before the end of our seven-year project is around 10 percent. We consider our art/life experiments a great success.

BETH: There are a lot of people who want art to reaffirm their worldview. They want it to be beautiful, a purely aesthetic thing that is devoid of content. When I got into trouble at art school, it was the formalists who really criticized me, because I had committed the "crime" of actually making art that had content about life or politics or sex, and these were things that people just didn't want to think about when they looked at art. They wanted to think about craft or aesthetics, they wanted art about art, and they didn't want to have anything to do with it permeating that boundary between art and life.

ANNIE: I've always been an artist who's done art based on life. Like when I was doing porn, it was about the real sexual adventure, not some fantasy I made up. My work's always been about the real facts. While I honestly don't consider myself an exhibitionist, I am the kind of artist that likes to expose herself in various ways. Sharing honestly about our lives really helps us all, whether it's in a twelve-step meeting, in church, or through art. Making art helped me to both examine what I was experiencing, or to get my mind off it, and to contextualize my cancer, to write my own history about it. I absolutely don't want to be seen as a victim, because I'm not. Or for people to assume my breast cancer was a really bad experience, because it wasn't at all. Not this time. And hopefully there won't be a next time.

For more information on the Love Art Lab, go to
loveartlab.org

Elizabeth Stephens was born in West Virginia. She is Chair of the Art Department, Professor of Art and of Digital Art/New Media, and is affiliated with the Department of Feminist Studies at the University of California, Santa Cruz. Stephens is an inter-media artist who works in sculpture, video installation, photography, web-based media, performance art and home renovation. Her most recent works include the bronze sculptural installation, *The Academic/Porn Star Panty Collection*; the road trip performance piece *Wish You Were Here*; the video installation, *Kiss*, as well as her ongoing collaboration with Annie Sprinkle in the Love Art Laboratory. She has exhibited in museums, galleries and non-profit spaces throughout the United States, Europe, Asia and Russia.

Annie Sprinkle is based out of a lovely Victorian home in San Francisco with Elizabeth. In a former life Sprinkle was a proud prostitute, porn actress and pin-up model for twenty years in Manhattan. Then she became a full-time performance artist and toured her one-woman shows about her life in the sex industry all over the USA, and to many other countries. Her shows *Post Porn Modernist* and *Annie Sprinkle's Herstory of Porn* are studied in many Universities. Annie loves to conduct visiting artist lectures for adult students and teach them the Art of Making Love. She has written several published books, her last one being *Dr. Sprinkle's Spectacular Sex—Make Over Your Love Life* (Penguin). For more juicy details, vintage nude and fetish photos, writings and musings, and to collect Annie's art, books and DVDs, visit www.anniesprinkle.org.

Friends as Heroes

SILAS HOWARD

Fog swept over Twin Peaks like a slow-mo tsunami, blanketing the city from the sun. Another San Francisco morning. As daylight sucked the last hint of midnight blue from the sky, Harry, Lynny and I sat on a lumpy, thrifted brown couch talking our way through a crash down off cocaine. In between, we called the dealer, begging him to let us back in his apartment. He acted offended. He thought we wanted to be friends. We only used him for his drugs, he whimpered. *Please*. It was a familiar twisted ritual between the dealer and the dealt, between the need for human companionship and the deepseated desire to disappear.

We had no idea that little over six months from then we'd quit drugs and alcohol and be clean. Six months after getting clean, we'd begin to make art, create a performance space and play punk music. Sitting there on that dingy brown couch, it seemed impossible to believe that soon we'd begin a collaboration that would span the next twenty years.

I was raised near fields the color of a three-day-old bruise by a group of daydreaming, calamitous people in Vermont. My family wrote stories, painted pictures. Art was a simple act of survival and survival was an art form for us. A huge Warhol-ean mural filled an entire wall of the living room of my mother's apartment, which I visited on weekends.

We wore our misfortunes like a church lady's Sunday hat, all big and flashy and finished off with a bow. My father learned the names of the repo guys by heart. They visited our house so often, they sometimes stayed for dinner. My grandmother had a car that only ran in reverse, so she drove it backwards around town. We moved resourcefully when needed, which was often.

This is my memory of myself: a tough little kid, a stick-chewing boy fighter who brought grape flavored rolling papers to first grade for show and tell, explaining how they tasted like grape when you licked the glue to seal the joint. Friends from that time could tell what I had for breakfast by the color of my Kool-Aid mustache. Orange, purple, green...

The first thing I learned was how to entertain. By age seven, sitting cross-legged on my mom's huge stereo cabinet, I did a mean impersonation of Cheech and Chong for the bikers who passed around joints in a circle in our apartment. If I made them laugh it kept them from yelling at me, or worse, ignoring me. If I was funny, all was good. If I cried, I was told I looked ugly.

When the man who lived next door started to teach me how to french kiss and go to third base in the first grade, I realized there was another way to get attention besides entertaining people. Soon I

shared this information with my peers, playing "hitchhiker" and "trucker" with the girls I had crushes on. We were still too young to realize what the stakes were, but the adults sensed something was off—I became the kind of kid you didn't want your own kids around.

Shortly after the neighbor guy started messing with me, I began lying and skipping school, constructing a secret life. I started to believe *I* was the bad things that happened to me, that these inappropriate behaviors around me made up who I was in the world. I justified any lie or secret because it preserved a part of me untouched by anyone.

The first drug I discovered was fantasy. A great escape. As a kid, daydreams grew around me like kudzu and took shape. I dreamed of all the great things that lay ahead. My big plans to heal all pains.

Essentially there were two plans. One was to be famous and soon. I remember seeing a fifteen-year-old girl and thinking her life was over, because she had achieved nothing of grand importance yet. I was eleven at the time. The other big plan was to have a normal home and a normal family, like the ones I saw on TV: *The Waltons*, *Happy Days*, *Eight Is Enough* and *The Brady Bunch*.

If I couldn't save my family, I could save face by ignoring the chaos, like the way you ignore a mean dog—just look away and keep moving. One Christmas I remember my stepmom opening our balcony's sliding glass doors. We lived on the second floor, and the door was meant to open onto a balcony. Unfortunately the contactor ran out of money so the door open onto nothing—a clear drop. Frustrated by the state of our home—not so much home as a place, but

an irrevocable condition—she pushed the x-mas tree off the balcony—decorations, lights and all. It sat in the snow for week before we un-decorated it and dragged the dead tree the trash. The lights couldn't have been blinking in the snow; the cord would have unplugged. But I remember them blinking in the snow. That would have been better. Sadder. Happier. Both.

In fantasy, I could rewrite history, even if only for a moment.

In order to rise above our constant poverty I organized friends to enter contests from the backs of cereal boxes and planned our income, forgetting that we had to actually win first. When that didn't pan out I rethought my entrepreneurial plans. I realized I could steal one neighbor's flowers and sell them to the other neighbors. I picked this up from my dad, who often walked out of restaurants with an unpaid check hidden in his hand. Sometimes he'd come home from his job at a diner, a brown paper bag stuffed with cash register's content for that day. That meant it was time to move to the next town. By high school graduation I had attended ten schools.

In ninth grade I discovered alcohol, and all the missing pieces fell into place. It transformed me into a movie star. The daydreams moved from my mind into my limbs. Booze made me feel like I was running down hill. If I stopped, I'd fall, so I'd run faster and faster, laughing and scared. When I drank, I'd get that same feeling from the couch in our small north side apartment. It felt like going to the carnival; in one night, the familiar became the strange. All of a sudden I didn't care—I just *was*. I proceeded to drink until I blacked out, wishing to fall into a fairytale–like slumber and wake at some future point

where people made sense to me. But I didn't wake up. I landed a car in a tree. I tried to break windows with my fists. Having grown up in a crazy, unpredictable world, I found living in reality a restraining and nonsensical proposition. Eventually I started selling drugs. When people asked why I stole and lied, I lied.

Hardly anyone went to college from my school; most worked at a local mall or joined the army. I decided to apply, due to a certain teacher's relentless belief in me, and was accepted to New York University, Boston University, and Emerson. The tuition was out of my reach across the board, so when I found an aunt who agreed to house me for one month in San Francisco, I left. After years of moving within the tiny state of Vermont, at long last I could put as many miles as possible between my family and I.

I landed in San Francisco with sixty-five dollars and three weeks to find an apartment. The only thing cramping my new lifestyle and fresh start was the lifetime of bad habits that followed me there.

I found a job at a café where a co-worker said I should meet someone named Harry because we had a lot in common. "She's a Gemini like you, likes to party like you." Harry came in to scope me out. After a bit of chatting she left a note and three Satsuma oranges. The note was an offer to take a walk.

At the corner store, using fake IDs, we bought a bottle of wine. We built a fire in the backyard of an apartment in the Castro and talked. Harry told me how her seventeen-year-old mother put her up for adoption, and then she was adopted and grew up in the suburbs. She went on to tell how her birthmother supposedly lived in San Fran-

cisco and she often wondered if they ever passed one another of the street. I told her how I was also put up for adoption by my seventeen-year-old parents, who then changed their minds just as I was to be placed with a new family. Each of us lived the life the other almost had. This was a first night of our friendship, and already I had shared more with her than I had with anyone else before. We were two strangers adrift, trying to find beauty in broken things.

Lynny, a Tasmanian devil of a person with jet-black hair, who walked like a trucker crossed with an orangutan, used to approach Harry and I at the Albion, a bar our friend worked at. She called us scary punks because of our rag-tag Mohawks and our air of aloofness. Truth was, she kind of scared us. She would hold out a handful of melty chocolate covered espresso beans and ask, "Hey-ay scary dykes, wanna buzz ball, come on have a buzz ball." It was like an offer from the big bad wolf. Yet something about her attracted us, some spark of recognition that kept pulling us together. We were all passionate and bravely enduring, and most of all, longing for something else.

Together, the three of us drank and day dreamed. The dreaming was so perfect and drugs were like dreams in a top-notch movie theater, Dolby sound and a huge screen where you could project the best of yourself at volumes loud enough create a rumble in the chest. I felt the most honest on drugs, with no inhibitions, until sunrise when the chariot turned back into a pumpkin.

While high, Harry, Lynny and I, told stories that both mortified us and made us laugh uncontrollably. Our horror and laughter gave way

to amazement at the human talent for survival. With each hidden story revealed I became visible, which felt as painful as thawing out frostbitten feet, a rush of blood circulating and then sharp pains of revival.

The more visible I became, the more I could no longer ignore how my addiction was a slow death. I started to want a life I could actually remember. One day I walked into a smoke filled room with bad coffee and a set of rules written in red that looked like the rules at a pool and took a seat: Alcoholics Anonymous. I surrendered.

A few months after I got sober, Harry asked to join me at my next AA meeting. It was in a small, boxy, smoky room full of tough guys from the mission. One man, just out of prison, said, "There's only seventeen inches between my head and my heart. I'm trying to bridge that gap." He was tattooed and greasy haired and honest. It struck me mute.

On the wall was a huge, abstract painting of a feathery object with bright rays coming off it. The words at the top read *Hope is a thing with feathers that lives in the middle of your soul.* It sounded like someone swallowed a bird, which sounds uncomfortable, unpleasant, and kind of sad. Which, when I think about it, is perhaps what hope is.

Harry was sober for about two weeks when Lynny called asking to go to a meeting. My world started piecing back together as my friends and I continued to pull each other out of the mire by the scruff of the neck.

Lynny and I started a punk band out of a restless energy from new sobriety. We played at a party with the five songs we made up, and

repeated the set three times. The nights we used to spend up on drugs were now spent in a makeshift studio, drums filled with clothes to keep the neighbors from complaining. Sporting bad tattoos and worse hair, we took to the stage with our circus act. We acted as though the revolution we wanted to see had already happened.

A year or so after the band started, Harry and I started a café and produced shows with the goal of giving deadlines to our community of artists. They would have to choose, and make something if we booked them. Deep down we wanted that for ourselves. Like all do-good-ers, it was ourselves we really wanted to save. I remember certain moments when the café was packed with people, and some crazy thing was going on, Harry and I just looked over at each other beaming. We had created something.

No one talks about how the hardest thing about creating is grief. I think it's the act of choosing; means all the things you didn't chose, the ways it ballooned with small failures and beautiful beasts. But, once we quit drugs and alcohol, an amazing thing happened: we starting creating. We became the audience for one another, allowing each other to be the important person in the room. It was being true to ourselves like this that connected us to a whole world of people. Prior to that I had viewed the world a place to hide anything important to ensure it could never be taken away.

My grandfather has a super 8 home movie of me as a little kid, with fucked up crooked bangs, hiding behind my dad. I don't really think of the nervous, super shy kid in that movie as me. But she is, and she

breaks my heart. She's the part of me who couldn't take the pressure of it all, and the part I was most skilled at being mean to.

But that started to change around the time I met Harry.

Harry always saw bad luck as preventing her from some unknown worse luck, and therefore called it good. I loved that about her, the constant search to find meaning and some trust in a grander scheme. One such "lucky" break was her getting a ticket for tossing a cigarette out the window in Oregon. It meant she had to drive the fourteen hours to attend court and drive right back again. She slept in her truck, paid the ticket and came home. On the drive back, the plot for the story that became our film *By Hook or By Crook* came to life. It would be about a friendship. For us, friendship was how to find yourself. To make a difference. To be somebody. Which is all anyone wants anyway. That, and to be loved.

The film echoed ways Harry and I had inspired each other in what would amount today to twenty years of friendship. Our own exercise in wish fulfillment. We knew from experience how making new family gives you courage to make crazy art, loud music, and a big fool of yourself. We went from three gay punks who needed to be high just to talk to each other, terrified to explore the risks and rewards of human connection, to self-realized artists discovering the hidden strength behind things that only *seem* fragile.

This new world was the one we wanted to live in, full of fabulists and obsessive explicators. Where the person across the room tells your big secret out loud as their own and the laughter fills the room. It's magic—like breathing pure oxygen.

Silas Howard, (writer, director, and musician), co-directed her first feature, *By Hook Or By Crook*, with Harry Dodge. The indie classic was a 2002 Sundance Film Festival premiere and five-time Best Feature winner. Howard's next feature, *Exactly Like You*, (co-written with Nina Landey), is a Nantucket Screenwriters Colony 2004 fellow and finalist for the 2005 Sundance Filmmaker's lab. Howard's first short documentary, *What I Love About Dying* (2006), premiered at the 2006 Sundance Film Festival.

For eight years, Howard (*and Lynny*) toured nationally and internationally with her band, *Tribe 8*. The notorious punk band released four full-length recordings on Alternative Tentacles and was featured in *Rolling Stone, The Village Voice, Interview, Billboard, Elle* and *The Los Angeles Times*. A feature length documentary about the band, *Rise Above*, by Tracy Flannegan garnered several awards in 2004.

Rappin' My Wounds

TONI BLACKMAN

You have lived and loved with the intensity of a bandit on the run, and it frightens you more than anything in the world. The very thing you seek is what you shun the most. You are thwarted by your need to know, your fear of existing in that space of uncertainty.

He is looking into your eyes with a look that could kill. He tells you the look actually means he would kill "for you." Your laughter makes him dance, but he is too cool to sweat, to surrender to the music. He is a quasi-free spirit. A living, breathing paradox, he fears his own nakedness, but is most free when he is naked. His spirit only opens up when his head rests between the mounds of woman-ness, when his hands squeeze the thickness of soft, warm, thighs. Oh, how he sings and moans in those moments. His music becomes the beat for your latest creation.

> *Professor of love/Dr. Feelgood*
> *Knew every spot to kiss to make her go uhhh*
> *She felt his caress but did he ever really touch?*

The look in his eyes asks was it all too much?
The blending was heavenly
It had to be God, see
And neither took it lightly
Doin' things she never did before she said "bite me"
Each session a blessin'
Both releasin' stress and
Dealin' with the fear that comes when you come

You thought he had love for you. A girl, young and naïve, you thought he would love you because he said "I love you" on more than one occasion and you believed him because he meant it when he said it. You felt it, he felt it.

On the west side highway, at 50 mph, your finger in his face, both of your voices raised, he threatens to hit you. He grinds his knuckles in your jawbone to simulate where the punch would land. Your sunglasses fall from your face to the floor of the car. You muster a nervous laugh. It all happened so quickly. A CD of beats plays on repeat in the player. You close your eyes at the stoplight, writing rhymes in your mind, etching the lines into your memory.

He is a thief and she's in disbelief
That he would try to steal her peace
Of mind
A conversation of land mines
An explosion at anytime
Time, the enemy

Never a true friend to she
His sensitivity completely unreal
From the way she smiled
To her singing out loud
He even critiqued the way she stood in a crowd
Subtle manipulation infected their relations
He had never seen a love so true
Beyond the sex she offered respect
But with skin so thick
divine love couldn't get through

Your cousin looked into his eyes at first meeting. She told you he was red bone evil like Big Mama and "dem usedta" say. He never showed you this side of himself before. He told you of this side of himself before. You were forewarned.

His bedroom becomes a boxing ring, your apartment a battle-ground. He throws a verbal punch, jabs and moves to a neutral corner near the mantle. You counter punch while your words have you weaving in and out, blocking. You wonder if you should head down the stairs before it gets too ugly. He embraces you sensually while trying his best to convince you it is not a sexual hug, that you are making this up in your head.

It started with a kiss
How did it come to this
Used my heart and not my head
All I got was pain-filled bliss

And the imprint of his fist
I understood the prediction
Warning signs of his affliction
Friction and anger meant danger
It had little to do with me
Still it filled my drama tendencies
One day he'd bring the pain
The next day hold me lovingly

He tells you that you mustn't have sex with him. The next week he is having sex with you.

Your insanity is his insanity. His crazy belongs to you. You are his reflection. He is yours. His calling you crazy pushes you to tears on two occasions. "I am an adult trying to have a conversation with a lunatic!" he yells. His thumb catches your tears—a substitute for tissue. His lips upon yours—an apology. His embrace, filled with regret and completion; you know he will never hurl that brick in your direction again.

The little girl in you wants to love him. She wants to make the nonsense make sense. She wants to believe that at some point you two were friends. She is unable to digest the hate he feels while saying "I love you."

After seeing a documentary he calls to admit that he used to be a misogynist. You know that he still is, having realized it when he told you he only talks on his cell phone a lot when it's "new pussy." You are getting to know him beneath the mask. Right about now, you can smell new pussy. New pussy lies on the horizon.

He tells you he does not want you. He tells you this after a morning of lovemaking, after he knows he has touched your soul. His eyes tell you that you too have touched his. His voice shakes as he speaks. His fear is familiar; the coldness, however, is coming from someplace you have never traveled with him. He seems to be enjoying this moment, this possibility of seeing you hurting, of seeing you uncomfortable, of proving to you that he does not love you, that it is obvious you love him more. He needs you to know that he is not in love with you. He sees your calm. He knows that a song is to come. He knows that a poem dances on your tongue, is simmering in your mind.

I'm dealin' with this dude
Who gets a little rude
'coz he's a little comfy with me
each time a woman pass
his ass is watching ass
and he use the word bitch quite freely
thoughts in my mind flippin'
I'm thinkin' I'm trippin'
Overreacting and such
Thinking just way too much
So I—
Keep these thoughts inside
True feelin's I hide
Doin' my best to enjoy the ride
But he makes it kinda hard

> *'Coz he speaks so clearly of God*
> *The love of his people and*
> *Women being equal*
> *But with him it's like a movie*
> *...I won't be here for the sequel*

He speaks to fill the quiet. His breathing is uneasy. He acts out, you respond with love and newness. He tells you to go away. You go away. He is afraid you will leave. You do not leave. He pushes you away. You know that the BPM of his track does not suit your lyric, does not honor your voice. You know that even the friendship must come to an end.

He asks, "Why are you still fuckin' me?" His lean frame still fully unclothed as he lays across your bed. Checking email is your distraction; you glance at him quickly, but long enough to see the fear in his eyes. He has two faces—one of his own and the other an angry nine-year-old boy. He doesn't want to feel anything. You begin the release and the poem while he is sleeping.

> *A conscious rapper*
> *Unconsciously he slapped her*
> *With a verbal jab*
> *With a knife of negativity*
> *He stabbed her*
> *Over and over again*
> *The rage in his eyes*
> *It just wouldn't end*

She gave and she gave
Thought at least
We could be friends
But there was a tear in the fabric
Of his heart only he could mend

He insists he is the daddy in this relationship. You agree with him that it began in that space. He designed it to be that way. He tells you, we can never have a peer-to-peer conversation because there is only one adult.

Little black girls who didn't have daddies often attract a certain kind of guy. These little girls believe that his nationalist rhetoric means that his love for black people includes black women. They want to believe that the books on his shelf, the ankh around his wrist and the oils on his skin represent his connectedness. You believe that this strong, opinionated spirit will protect you. He tells you he has come for that purpose. He tells you he was sent by the ancestors and you so badly want this to be true. This patriarchal figure of knowledge, wisdom and understanding dressed in spiritual whites. Raised in a culture of tradition he came for you on a beach while down south, touched you in the dark of the night. Stories he shared then, you understand now.

It is Father's Day and she has something to say
About what he forgot and what he ignored
There was a little girl who adored/Daddy
Couldn't be the man he meant to be

He tried to get free
But his path was tainted
The walls of his life were painted
Lived a hustler's life
Post-slavery trauma com-piled the strife
But things like this don't get discussed
Amongst family there's a secret trust
Where the women either bust/burst or
Completely hold it in
Cancerous beginnings
Passed onto the children
Daddy-less daughters learn on their own
Painful teachings once they get grown
Dealin' with dudes that are rude
Whose treatment is crude
Thinkin' he'll change if she just gives
Not knowin' the more controlling a man is
The less control he has in the life he lives

You tell him that this is abuse. He laughs. He defends. He blames. He accepts no responsibility. You tell him he should ask his mother for her opinion, but know that your voice is a muffled blur in his ears.

He has used your secrets as weapons in verbal warfare. He berates you and puts down your work. He tells you how to speak at meetings, how to stand in line, which shoes go with which skirt. He tells you which of your friends are cute and which ones are not. He intends to hurt. He was taught that criticism is love. It is not.

He tells you that you musn't feel so beneath him. Your thoughts racing through fast comebacks, looking for hurtful truths that could be hurled in his direction, searching for clever sarcasm that might leave an emotional black eye. You withhold what you know could leave a scar. You wish you could understand why he so desperately wants to push you out of his life, the very person who shows up when he calls, who comes through when he needs, who forgives when he wrongs. He is sabotaging every ounce of friendship.

> *When a man has no power*
> *He might try to tower*
> *In other parts of his life*
> *He may inflict strife*
> *On those around him*
> *Educated and a leader*
> *he could still be trife*
> *even after therapy*
> *it's up to him to get free*
> *he says that he loves her*
> *but can't seem to show it*
> *takes what he needs from the garden*
> *does nothing to grow it*

Once home, you pour yourself into your bed like warm cider on a winter night. He wants you to be different, to be like him, think like him, talk like him and you want to simply be. Even his best attempts at apologies feel like intentional disses. If he could freestyle he would

have battled you by now, but he cannot so instead he calls you names and tells you how wack you are. You wonder why he cannot simply say, "I am sorry for the hurt that I caused you. I am sorry for hitting you. I am sorry for yelling at you. I am sorry for making you cry. I am sorry for manipulating you and treating you unfairly. I am sorry for taking you for granted." You want to speak to him, but the clock says 2 a.m. and your gut says "don't," so you speak to God.

You chant, you pray, you release. You run beats on your itunes and wonder if your neighbor is wondering who it is you are performing for at 3 a.m. in the morning. *It's 5 o'clock in the morning where you gon' be?* Through the night, all night, in the mirror, in the middle of the living room floor. On the bed, in the bed, beats bangin'

> *She was amazed by how slowly the days went by*
> *Wishing life was a tape she could rewind*
> *Offered up praise as she raised her hands in the sky an' started*
> * to cry*
> *Promised she'd learned this lesson for the last time*

Wrapped in the sheets, you rap yourself to sleep knowing this is not the first baggage-laden brother with scars from childhood abuse that you will know. You also know this will not be the last. He is your lesson. You practice *dealin'* with, instead of running. You practice protecting yourself.

You read books, perform prayers and meditations, even sit at the feet of elders with hopes of transforming your heart. You write until your fingers are numb. You find that your love for yourself has

grown. You love yourself more than you love him. You know that your pain will translate into power onstage. So you write poems. You spit rhymes. You rock mics.

Toni Blackman was the first Hip Hop artist selected to work as a Cultural Ambassador traveling with the US Department of State. She has traveled throughout Africa and Southeast Asia, often working in some of the world's most war-torn nation states to help bring reconciliation and rehabilitation to those regions. She has also traveled the globe as a lyrical performance specialist, performing in Europe, Canada, and the United States. Toni's first book *Inner-Course* (Villard/Random House) was released in late 2003. She is currently working on a second book that details her plight as the first Hip Hop Ambassador for the State Department.

The Artful Art of the Role of Art in the Ugly Art of Survival

DIANE DIMASSA

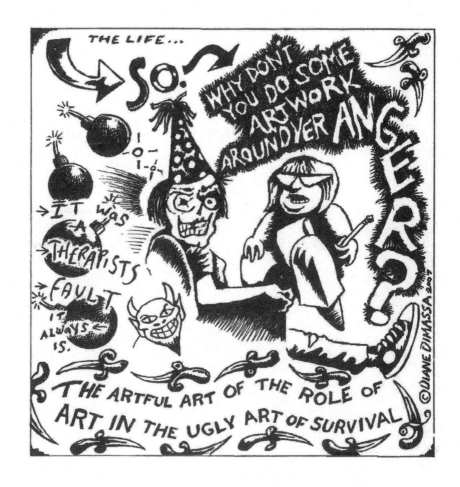

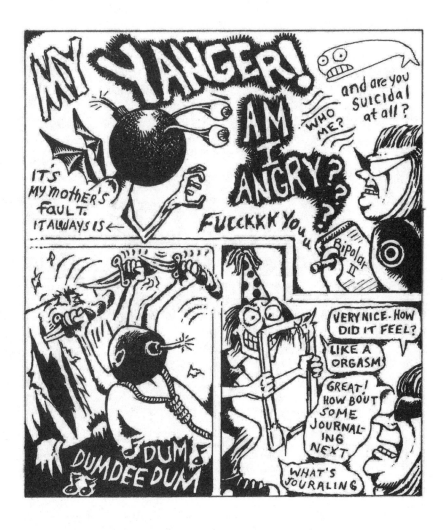

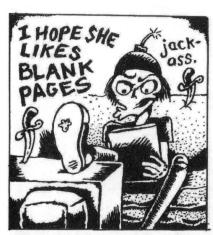

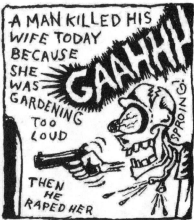

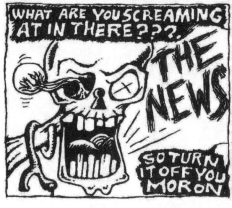

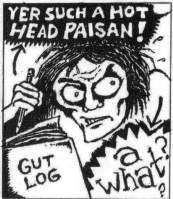

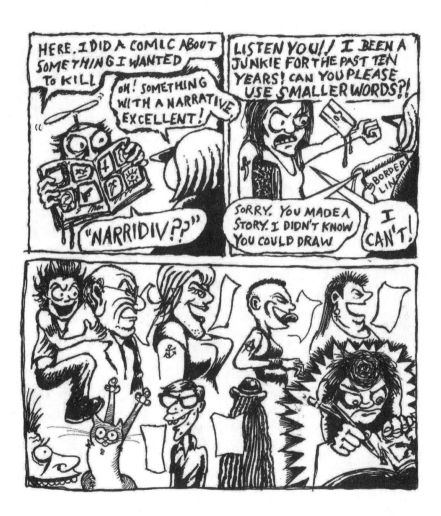

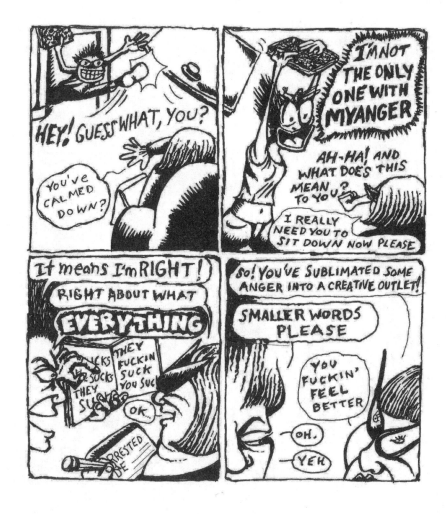

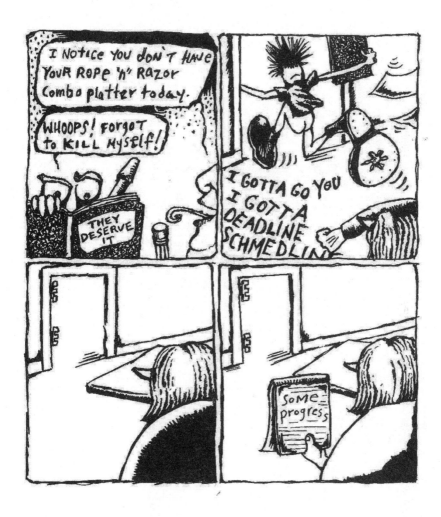

Diane DiMassa is best known as the creator of the cult comic heroine Hothead Paisan, Homicidal Lesbian Terrorist. She recently illustrated a graphic novel written by Daphne Gottlieb called *Jokes and the Unconcious* (Cleis Press), and regularly contributes to anthologies, etc.

Weight Watcher

STEPHANIE HOWELL

Ten pounds, eight ounces

I was a fat baby girl. Photographs capture my round chubby face and my round chubby body. I was a pink little piggy, minus the snout and tail. My baby fat stayed with me as I aged. And I was continually reminded of that fact. Barnyard animals became adjectives used to describe me. I grew from a cute little piggy to a pig.

One day riding on the school bus, I discovered that my animal status had been documented. I noticed a discarded yearbook. As I flipped through it to figure out who it belonged to, I saw my photograph. A voice inside my head told me not to cry. As I blinked back the tears, I stared at my picture and the commentary. Someone had taken a black pen and scrawled "Fat Pig" above my face. I didn't cry on the bus, but when I was in the safety of my bedroom closet, the tears flowed. I was seven years old.

Pigs weren't the only barnyard animals that I was compared to. I knew from the boys and girls on the playground that I looked like a "cow" and I that I must have had an appetite "like a horse." And it wasn't limited to barnyard animals either. I was weighed against many large mammals—whale, elephant, hippopotamus, rhinoceros, and manatee. Kids can be cruel; adults, too. I remember listening to concerned relatives informing me that I needed to go on a diet to lose my baby fat because I was no longer a baby. As a young girl, I loved gymnastics—I wanted to be the next Nadia Comaneci. I wore my pink leotard as I performed cartwheels and front-flips at the family picnic. I felt such a sense of pride as I did my routine; I didn't fall, I was graceful, I was light on my feet—I thought I was good; a perfect "10." In my young girl's imagination, I expected applause and praise from my audience. Instead, I was pulled aside by my aunt and was told to "cover myself up." I was too "fat" to wear a leotard. I didn't eat at that picnic and I never wore that leotard again.

Oh, I was a fattie. But more importantly, I knew what it meant to be a fattie at such a young age—I knew it meant that I was less than, that I was worthless, that I was to be embarrassed by my body and my size.

146 pounds

As my age increased, the number on the scale followed suit. At twelve, my fellow sixth-grade classmates and I were weighed in front of one another in the school cafeteria. I started to panic as my classmates stepped up to the scale and our teacher announced and recorded their weight. How could I get out of this situation? Could I

fake an illness? Will myself to be invisible? I did not want to do this! I knew, we all knew, I was the fattest kid in class; why did I have to be weighed to prove it? Before I stepped on that scale, I knew that I was going to be shamed. As my worth was announced—146 pounds—I could feel their eyes upon me and the laughter of their voices. I was humiliated. I went home that evening and I prayed to God for a miracle: "Please, let me be like the other kids; let me wake up tomorrow and be skinny and normal." It didn't happen.

181 pounds

I was a freshman in high school when I was faced with the choice of taking either a public speaking class or beginning acting class. I wanted another choice. Why wasn't there an oral communication class where I could just fade into the background—not be seen, not be heard, not have eyes placed upon me? I weighed my options. In the public speaking class, it would be "Stephanie" standing before her audience. "Stephanie" would have to craft a speech and say her words. "Stephanie" would have to acknowledge her audience members. "Stephanie" would not be able to hide. But in the beginner's acting class, I wouldn't have to be "Stephanie" standing before an audience—I could be someone else. "Stephanie" wouldn't have to speak—I could speak someone else's words. "Stephanie" wouldn't have to look at the audience but, more importantly, the audience wouldn't be looking at "Stephanie." Instead, they would be seeing a character—someone other than "the fat girl." I chose the acting class.

Being a member in the beginner's acting class wasn't easy. I was still fat, but I was able to hide behind my fat—"I" was able to hide

behind a character. In my character, I was able to transcend my fat-ness; I was able to be something other than "fat." For example, I was able to embody a weasel from the play *The Wind in the Willows* and to craft this character in a way which was engaging to the audience members as I scampered and scurried across the stage. Acting was a release for me. While I never was cast as the ingénue, I had lots of fun playing wacky, funny roles. I loved the applause; I was being acknowledged for my talent and not my body per se.

199 pounds

I was sixteen years old and I wore a size sixteen pant. My mother, who was looking out for my best interest, suggested that I join a weight loss group. A trip to the local TOPS—Take Off Pounds Sensi-bly—was a pinnacle in the ways in which my weight was watched by others and the ways in which my weight was watched by my own eyes. I embarked upon the physical erasure of my body.

I called it "the zone." Being in "the zone" consisted of two basic principles—starvation and exercise. I never did take off pounds sen-sibly. I refrained from eating and I exercised for hours at a time. I began to challenge myself—how many days could I go without eat-ing? One day? Three days? Five days? (The longest I could go without eating food was seven days.) Could I go one, two, or three hours a night riding my stationary bike without stopping? (I could go four hours a night riding my stationary bike without stopping.) Every time my stomach "growled" for food, I imagined the hunger pain wearing boxing gloves punching at the fat—punching out the fat. Every time I felt overcome by the wave of hunger, I experienced

a sense of comfort because I knew that it meant I was losing weight. I wore layers of clothes as I exercised—long johns, sweatpants and sweatshirts, even a rubber suit. I got unbearably hot and sweaty as I rode my stationary bike. Each drop of sweat represented a fat cell being drained.

The first week at TOPS, I lost six pounds. The applause I received from my fellow TOPS members when I announced my weight loss was exciting—it was similar to the way I felt when I was performing onstage; I was being applauded for my weight loss talent. The second week at TOPS, I lost five pounds. I received applause once again. The third week, I lost four pounds. In three weeks, I had lost fifteen pounds—members were curious to know my secret. I became obsessed with the scale, obsessed with "the zone," and obsessed with my weight loss. And as I continued to lose weight, others began to notice. Various teachers remarked on the shape of my body. Some kids even stopped me in the hall to ask me if I was losing weight. I would shrug and reply, "I don't know," lying through my teeth. I knew exactly how much weight I had lost.

I lost thirty-nine pounds at TOPS before the weight loss suddenly stopped. My body shut down. I had no energy. The simple act of getting up from a sitting position was no longer a simple act. I would feel intense pressure in my head, hear a strange buzzing sound in my ears, and lose focus of what I was looking at. After days, weeks, and months of being deprived of food and nourishment, my body refused to give another ounce, another pound, to my obsession. With my height and bone structure, I was thin at 160 pounds. My collarbone was prominent and my hipbones were visible. I didn't see that, I only

saw fat. And I was still called "fat." I continued starving myself. I continued my exercise regimen.

When I was in "the zone" and starving myself, I don't mean to imply that I didn't eat. What it means is that I ate as little as possible and it was important that I ate on a schedule. A typical breakfast consisted of nothing. Lunch was at noon and it was a diet cola. Dinner happened at four in the afternoon—a diet soda and one hamburger from McDonalds. This was my daily routine.

It was important that I followed my daily routine. When I followed the routine I was strong, I embodied willpower, and I felt calm. Any deviation from my daily routine would bring hours of emotional terrorism and torture that I would bring upon myself—"You are so stupid," "You are such a pig," "You are never going to amount to anything," "It would be better if you were dead."

I was hungry. It wasn't time to eat. It wasn't part of the routine. Just this once, I would allow myself to feed the hunger and eat a cracker. I didn't stop with a cracker. The cracker gave way to a piece of cheese. The piece of cheese led to a slice of pizza. A person can't eat a slice of pizza without enjoying a nice cold soda. Since I'd already had one piece of pizza, I'd fucked it up, and I proceeded to eat another slice, and drink another cola. In this way, as quickly as I could slip into "the zone," I could slip out of it. I could lose five pounds at the drop of a hat. Then, gain five pounds by looking too long at something fattening. Clichés, I know—but true.

The cycle of weight watching, weight gain, and weight loss stayed with me through my teen years and into my twenties. I can't remember why I dropped out of college the first time, but I can remember

that I weighed 183 pounds. I have no idea what present(s) I got for my twenty-fourth birthday but I know how much I weighed—219 pounds. I don't recall the moment Steve and I first kissed but I know I weighed 245 pounds. I can't remember where I celebrated New Year's Eve when I was twenty-six but, I know that I weighed 235 and my resolution that year was to lose 100 pounds. I can't remember how much gas I was putting into my car when I was at a Shell station and a car full of boys yelled, "Hey fattie, want a date?" I weighed 256 pounds.

235 pounds

I was twenty-nine years old and I decided that I wanted to be an actor. Interestingly, I chose a profession that is hyper-focused on how one looks. Very rarely does one hear "Can she play the part?" More often than not, one will hear "Does she look the part?" I was still struggling with my body image and my relationship with food, but I knew I was good at acting and there was a niche for "fat" actresses. Many thin actresses won't gain weight for a stage role— unless there is the possibility of a Tony nomination. I was already fat and someone has to play the fat roles. Plus, if I started losing or gaining weight quickly I could always blame it on my "character." Interestingly enough, during my time at college I was cast as Lilith— a character who struggles with an eating disorder. I lost twenty pounds before the show opened by eating only salads and drinking diet soda, grapefruit juice, and water. Art imitating life, life imitating art.

251 pounds

Then I auditioned for the musical, *Gypsy*. It was a large cattle-call audition and, to my surprise, I was hired by a company and cast as one of the strippers in the show—Mazeppa. In all the other productions I had been involved with, my body had been covered from head to toe. This show was different; I could hide behind my character, but ultimately, I was going to have to show "my" body—my fat and flabby body. Mazeppa's costume didn't leave much to the imagination—a black and brown brassiere, a short black and brown skirt, tights, a headpiece, and dance shoes. I was embarrassed each time I went in for a costume fitting. I was the only fat person in the cast. My fellow strippers—Electra and Tessie—were skinny actresses. Regardless of my size, each time I went in for fitting, my body wasn't critiqued. In fact, time after time, I was told how "great" I looked in my costume.

The rehearsal period for *Gypsy* lasted three weeks. I could not avoid the mirrors. In the rehearsal hall, I was surrounded by them—mirrors in front of me, behind me, to the sides of me; I was in a cage of them. I couldn't escape the shape of my breasts, my ass, and my hips. I couldn't escape the ways in which my hips swayed side to side. I couldn't escape the ways in which I would roll my shoulders into a mean shimmy. I couldn't escape the ways in which I would shake my ass. I also couldn't escape the ways others viewed my body. None of my fellow cast mates laughed at my body as I performed in rehearsal. My director told me that I looked "sexy and salacious" as I was dancing and singing. At the time, I had no idea of what "salacious" meant. It wasn't until I had the opportunity to look



it up in the dictionary that I knew salacious meant "mouthwatering."

I was suspicious of my costumer, my fellow cast mates, and my director. But, I could not be suspicious of paying audience members. *Gypsy* ran for two weeks. Opening night, I worried how the audience would view my fat body in my skimpy costume. I waited behind the backstage curtain—nervously— for my cue to enter. When I heard Tessie give her line, I exited the wings and took center stage. As soon as I stepped foot onstage, I heard laughter from the audience. At that moment, I believed that they were laughing at me and my fat body— I wanted to die but I knew the show must go on and Electra, Tessie, and I had our song to sing. I was the lead into the song and I embodied fearlessness as I sang my part and moved my body. I felt a shift in the audience; I heard folks whistling and cheering as I belted out the words. When I finished my solo I was shocked by how my audience members reacted. All of a sudden, they got on their feet—a standing ovation. A standing ovation that wouldn't stop. A standing ovation that halted the orchestra. I stood there smiling in amazement. I graciously took my bow. This was not a one-time experience. *Gypsy* was performed sixteen times and each time I sang my solo I received a standing ovation. And as a side note, I found out that when I first stepped onstage opening night, the audience wasn't laughing at my body. It was my headpiece they found funny.

It was through performing Mazeppa and embracing fearlessness that I was able to construct a new understanding of "fat" and the "performance of fatness" in my live performances. I made the conscious decision that I didn't have to hate my body anymore. I didn't have to hide my body anymore—I didn't have to be ashamed of my

fatness. That's not to say that newfound acceptance of my fat body happened overnight—it didn't. This was a slow, slow process. A slow process that began with me being grateful that I had a working and functional body—I hadn't damaged my physical body through my own abuse. Through this appreciation, I was able to see my body in a different light. Fat didn't mean "bad," "unworthy," "unlovable," or "undesirable." I began wearing clothing that fit close to my body. I wanted people to see my fatness. I would no longer be invisible. This appreciation of my fatness sparked my professional work.

In graduate school, I read various artists/scholars who utilized their bodies in performance. I was particularly interested in the ones who embraced the abject with their work. I was moved by Karen Finley and the ways in which she constructed and deconstructed the "hysterical woman." I was enthralled by the ways in which French Performance Artist Orlan manipulated the construction and deconstruction of "beauty." I wanted to be like Tim Miller and explore the construction and deconstruction of "touching bodies." I fell in love with Annie Sprinkle and the ways in which she constructed and deconstructed her various bodies—"porn-star, whore, goddess, and cancer survivor."

Inspired by these artists/scholars, I began writing about my experiences being a fat woman in US culture. I wrote about the practices of looking, the gaze, and the consumption of bodies. I wrote about the construction of fatness and deconstructed stereotypes regarding "fatness." I implicated my audiences, I critiqued my audiences, and I revealed to my audiences what it is to live in a fat body in my writing. But in all of my writing, I was unable to make the physical

connection to my audience members that I desired. I needed to move beyond the written word on the page and place my fat body in real space and time.

> *"Weight Watchers.*
> *Weight Watchers?*
> *Weight Watchers!*
> *Aren't we all weight watchers—watchers of weight?"*

I opened with these words in my performance piece entitled *Keep Staring*. This particular performance piece is the first show I wrote and performed on the stage that deals with issues surrounding weight watching, my relationship with food, and body image. With this particular show, I place my fat body on display upon the stage. As I am sitting on display, I partake in the act of eating—a large piece of cake. I watch my audience as they watch me. I take my time and I indulge in my eating. The act of a woman eating in public, regardless if she is fat or thin, is a taboo, and I milk it for all I can. While I indulge in my eating, I want my audience to reflect upon their own eating practices. I wait, wait for their reactions. I watch as some of my audience members smile at me. I watch as some of my audience members avert my gaze. I watch as some of my audience members look at me with disdain. When I finally begin my narrative, it is as though a weight is lifted off of my audience members' shoulders. No longer do they have to sit and watch me eat. As I share with my audience members the ways in which we are all weight watchers, watchers of weight, I begin to lift my shirt—revealing my stomach. The act of

showing my fat stomach to my audience is an act of empowerment—my flesh is my voice and my voice is my flesh. I watch my audience members as my audience members watch me as I talk about my fat belly, about the ways in which my belly is soft and warm; how my fat belly is comfort; how my fat belly is not to be feared. I watch my audience watching me. I offer my fat belly to my audience; I encourage them to touch, to stroke, to feel. I invite connection. I watch as they line up. I watch as some tentatively touch my fat belly. I watch their faces. I watch and listen as they share their stories of shame. I watch them cry as I hug them. I watch as some of them smile and kiss my belly. I listen when they thank me for being "brave." I watch as some of them walk through the theater to the exit doors. I do not get upset. I know that weight watching is a process. And just because some audience members leave, it doesn't mean they haven't been touched.

Through my everyday lived experiences, the embracing of my performance of fatness, and my solo performance work, I have moved through being a weight watcher to becoming a watcher of the weight watcher, a watcher of the watcher of weight. My work has evolved to inviting audience members ways to subvert "fat" ideology in US culture. I encourage them to reclaim and reconstruct the meaning of "fat." Because one is fat that does not necessarily mean that one is unhealthy. When I am out and about performing, I invite my audience members to go for a walk with me. When I am out and about performing, I invite my audience members to break bread with me. When I am out and about performing, I invite my audience members to love and embrace their bodies, no matter what the number on the scale is. All bodies are worthy bodies.

I still struggle. There are moments when I fall into old patterns, questioning the caloric content and/or the fat content of a food; I'll skip a meal, and/or believe that my fat body is bad. But, more often than not, I embrace my weight and body; I celebrate my body, warts and all, fat and all. It is the struggle and tension, the love and appreciation, the self-doubt and pressure to be skinny that allows me the opportunity to explore, engage in reflexivity, and create my art.

This morning I weighed myself—238 fabulous pounds.

Stephanie Howell is a performance artist whose work is based in identity, the performance of fatness, and burlesquing the body. She has performed at various theaters, universities, and performance spaces across the US. She teaches performance and communication studies at the College of Communication at DePaul University.

Rewriting the Script

CAROLYN GAGE

How on earth can you tell a story you can't remember? And what happens when you must tell this irretrievable story or else it will destroy you? And what if, in the story, the victims become the villains and vice versa? Is it possible to tell a story where the context is the true killer?

I was raised in an upper-middle-class home where my mother was alcoholic and my father suffered from what some feminists like to characterize as "Delusional Dominance Disorder," as well as severe dissociative disorders that played themselves out something like multiple personalities. Sometimes he was the Calvinistic tyrant, piously intoning family prayers over his cowering brood. At other times, he was the sadist, taunting and testing his dependents in erotically charged displays of his near-omnipotent hold over us. Occasionally, he was violent, but it was a violence always circumscribed by his concern for reputation and social standing—a

concern shared by my mother, who was as eager to disguise her vic-
tim status as he was to disguise his perpetrations. I can remember
her explaining away a black eye with a joke about her husband beat-
ing her, followed by a casual acknowledgment: "I really just ran into
a door."

If she, with her visible bruising and a memory intact enough to
make jokes about, ran into a door, what was it that I ran into? I, who
had no scars to even hide, no memories to even lie about? Whatever
it was that I ran into, or that ran into me, marked me for life—albeit
invisibly—in every single area of my being: socially, sexually, finan-
cially, intellectually, spiritually. Whatever it was had to have been
something far weightier than a person, or even persons.

If I wanted to know what happened to me, I would have to study
my own dramas.

By the time I was five, I was already saving my life by playing with
dolls. And when I say "playing with dolls" I don't mean dressing them
up and undressing them, or having little tea parties for them. I mean
using them as actors in elaborately scripted dramas that would last
up to six hours a session and whose plotlines, like BBC miniseries,
could stretch across weeks or even months.

My dollhouse had five stories and took up an entire wall of my
bedroom. It had been built by my cousins out of raw plywood, and
the only thing that distinguished it from a stack of crates was the
beveled roof. I didn't mind this at all. I embellished it with my imag-

ination. A glass candy dish would become a fountain as magnificent in my mind as the Fountain of Diana at Fontainebleau. Corn silk would serve as a plate of spaghetti. Everything I saw was evaluated in light of its potential as a dollhouse furnishing. I didn't need expensive miniatures. In fact, I disdained them. I wanted to inhabit a world of suggestion. I had learned that everything else is mutable, destructible. Suggestion is public privacy, hiding in plain sight. That was my method of operation. Scavenging became the ethical core of my interactions with the adult world.

The dolls were the focus of my life for almost ten years. There were more than fifty of them, acquired as gifts or as hand-me-downs, and occasionally as found persons. They each had names and specific personalities, and they each had their own place in the palace hierarchy. The Queen of the dollhouse was Ginny, my first doll—who, coincidentally, resembled my first girlfriend, the golden-haired and blue-eyed, six-year-old Mary W. Mary W. had been a sunny, simple girl who accepted as her due the fact that she was cherished by her family. Where my world was multi-layered and treacherous, requiring vast amounts of energy to reconcile or repress the overwhelming incoherence of atrocity, hers appeared to be a garden of delights from which anything unpleasant or harmful had already been banished.

Mary W. never returned the passion I had for her. Maybe this was because she could not comprehend the complexity and torment of my life, or maybe it was because my intensity scared or repelled her. Or maybe she didn't even notice. After fourth grade, she transferred to a different school and our friendship died a more or less natural

death from neglect. But, by that time, her doll counterpart, Ginny, was fully ensconced as the goddess of my alternative world. Ginny was the Queen. She was always wise, always compassionate, and her power was absolute—but not in the ways of human dictatorship. Unlike the sadistic, patriarchal god who sets his misbegotten world into motion for the thrill of watching it careen toward certain destruction, Ginny was one with her universe. She was the embodiment of it. It was not a question of will, but of rhythm.

As I said, when I played with my dolls it was not fashion shows or tea parties. I believe I was engaged in a form of sacred ritual. Or, maybe I was more like a scientist, testing out various theories of ethics in a microcosmic laboratory. Certainly, I was making detailed observations about human nature. I was rising to meet the daily banalities of my oppression with something more than resignation or identification with the perpetrator.

In the world of the dolls, I conjured. Literally entranced, I was enacting epic confrontations between the manifestations of patriarchal evil and the incontrovertible power of an overriding matriarchal consciousness. In my world, it was never a question who would win.

The heroine of my dramas was a different doll, equally beloved, but much more human. This doll was named Pat, and she had a history as complicated as my own. She had been abused and then rejected by my neighbors, the Wallaces. Pat's hair had been ruthlessly pulled out or cut off, and her body had been tattooed by various ballpoint pen markings. When I found her, she was naked. Pat, a predecessor to Barbie, was not a child doll, nor was she an adult. She had the beginnings of breasts, but not the pointed toes or the tiny waist.

I rescued Pat, and introduced her into the royal family of the dolls. Her background was unknown, but she possessed an unmistakable nobility of spirit that put most of the members of the court to shame. She had obviously survived some terrible personal tragedy, which, for some reason, was never discussed by either me or by the other dolls. She had no family, and I made no effort to create one for her.

Pat was, of course, a dyke and a survivor of incest trauma. This was the late 1950's, and it would be two more decades before I would claim those identities as my own. But I had created her, obviously, in my own image. No matter what evils befell her (and these were many), she always emerged triumphant, vindicated, restored to her rightful position. She was never angry, never jealous, but her protection lay in her absolute integrity, her innate sweetness—a kind of fierce innocence. And, of course, she had access to magic. The fairies and other supernatural beings of Ginny's realm favored her above all the other dolls, and, although this favoritism did not spare her from the trials that constituted my major plot device, these magical helpers made sure that the harsh experiences brought on by the jealousy and intrigues of the other dolls would only cause Pat's qualities to shine all the more.

When I turned thirteen, my mother announced that it was time to put away the dolls for good, and, in my first step toward becoming an adult, I believed her. We began to pack the dollhouse together, but very quickly, I became overwhelmed with distress. Sobbing hysteri-

cally, I fled from the room, leaving my mother to disassemble my childhood.

Why did I run away? Why hadn't I challenged her? Why hadn't I put up the fight of my life for these dearest of friends, these boon companions with whom I had gone on so many adventures? I knew that what was happening that afternoon was nothing less than a massacre. We were killing off the dolls. Why didn't I fight? I suspect it had something to do with "normalcy."

I was entering puberty. For the first time, there was a possibility that I might have the power to determine the course of my life, to affect my own reality. Perhaps I would be able to live my adventures, my romances, my fairy tales in the *real* world. I believe it was this hope, this promise of a normal life, that seduced me into the abandonment of my dolls. I had abandoned them, but I had not participated in the putting away of them. As the saying goes, "The coward who runs away may live to fight another day."

There is a popular song from the 1970s that contains the lyric "Every form of refuge has its price." The price I paid for my dissociative delights among the dolls was an emergence into adolescence with an overabundance of romantic scenarios and very little experience with real relationships, including one with myself. The only tools with which I was adept were magical thinking and denial, and those became my compass and sextant for navigating through life. Charting my course for perpetually elusive, mythical destinations, I ignored the small-craft wreckage I was leaving in my wake.

Fast-forward twenty years. I am in a life-size dollhouse now: married, working at "job-ettes," deeply involved in a homophobic christian church. But, I have begun to write.

My first play is about Virginia Woolf's involvement with working-class women's labor organizations. Hmm . . . An upper-middle-class married woman beginning to reach out to working-class women striving for economic independence. My second play is even more explicit: four women in the process of leaving their marriages. The third is a musical about women in theatre and how they overcame the misogyny that threatened to ruin their lives.

I am in a million-dollar lawsuit against a state university. I had resigned a doctoral fellowship in order to blow the whistle on a credit scam they were running in their graduate program. I have refused an offer to settle the case and I am demanding to have my day in court. The Attorney General has ramped up the witch-hunt. Like Alice after eating the mushroom, I am beginning to grow at an alarming rate. Suddenly, my marriage, my church, my social life, my conservative career goals don't fit me anymore. I am breaking everything I touch. Nobody knows what to do with me when I take up so much space.

My marriage ends. I leave my church. My lawsuit is thrown out by the state supreme court and settled for a pittance in tort claim court. I move to a lesbian neighborhood, to an all-women apartment building. I come out. And I begin to recover the emotional memories of my childhood abuse. I estrange from my family. I confront my father on the sexual abuse. Circulation is restored to my previously frost-bitten emotions, and the thaw is excruciating. I am overwhelmed with loss and enraged over the decades of discrimination and abuse.

My anger toward men is uncontainable. I begin to physically assault my harassers on the street.

What saves me from insanity and suicide? The plays. I am writing now as if my life depended on it, and it does. Too old for dolls, I am desperate to create alternative models for reality and to inhabit them. I write a one-woman play about Joan of Arc, which enables me to deal with my legal battles, with being scapegoated and being witch-hunted. In my play, Joan is resurrected as a lesbian separatist, recruiting armies of women to a militant feminist perspective. (This play will be my primary source of financial support for nearly a decade.)

I write a play about what happens to the women after they have been hanged for witchcraft in Arthur Miller's play *The Crucible*. Retracing my girlhood, I write the play *Ugly Ducklings*, about homophobia at a girls' summer camp. There is a ten-year-old girl who attempts to hang herself onstage. Twenty years later this play will become the basis of a documentary and a national campaign to prevent GLBT youth suicides. I write a play about English poet Vita Sackville-West and her lover Violet Trefusis and their train wreck of a relationship, derailed by homophobia and classism.

I remember this as a period of furious activity, as a kind of "hitting the rapids." Everything got pitched overboard: husband, house, family of birth, church, academic career, income, health. I lost the canoe, lost the paddles. Suddenly, it was just me trying to keep my head above the waves of guilt and shame, just me trying to navigate the turbulence of broken taboos.

I clung to this quotation by African American activist Ida Wells-Barnett:

"I felt that one had better die fighting against injustice than to die like a dog or a rat in a trap. I had already determined to sell my life as dearly as possible if attacked. I felt if I could take one lyncher with me, this would even up the score a little bit."

Wells-Barnett, the first African American to break the public silence about lynching, to dare to impugn white men as the true rapists, always carried a gun and made a point of letting others know that she did.

Like Wells-Barnett, I was also determined to "sell my life as dearly as possible." For me, this meant writing the most radical, the most militant, the most honest and dangerous plays that I possibly could, and producing and directing and even acting in them myself if that's what it took to get them out. In the words of feminist musician Ani DiFranco, "Every tool is a weapon if you hold it right." I honed my grip.

Many people have asked me why I have chosen playwriting over the seemingly more lucrative genres of screenwriting or composing novels. Why do I write for an institution so labor-intensive, so geographically restricted, and with such a short shelf life? Why do I write for live theatre?

The answer lies in the qualifier: "live." "Live," as in "taking place in real time" and "in front of living audiences." I never conceive of the people who see my plays as audiences. I think of them as participants, as active witnesses. They have the capacity to influence what

they are seeing. This is not true of audiences of electronic media, or readers of the written word. Perhaps the idea of a passive witness, one who does not influence what they are seeing, is something of a trigger for me.

Interestingly, one of the most effective modes of treatment for post-traumatic stress disorder is something called "exposure ther- apy," previously known as "imaginal flooding." This involves writing detailed narratives of the trauma and then reading the narratives aloud to the therapist or other patients. The "flooding" refers to the fact that these narratives have been painstakingly gone over, again and again, refined and edited, until the trauma becomes incorpo- rated. The witnessing aspect is a critical piece in the integration.

Before I even understood that I was a trauma survivor, I had already intuited that my salvation lay in presenting testimony in front of active witnesses, telling a story refined and attenuated by interminable rewrites and rehearsals until, like some kind of home- opathic emotional tincture, there remained no trace of the original traumatic affect—only the healing resonance.

This essay contains excerpts from an earlier essay, "My Life Among the Dolls," *Michi- gan Quarterly Review*, Spring 2000, Ann Arbor, MI.

Carolyn Gage is a lesbian-feminist playwright, performer, director and activist. She is the author of fifty-six plays and five books, four of which are on lesbian theatre. Her play *Ugly Ducklings* was nominated by the American Theatre Critics Association for the ATCA/Steinberg Award for best new play of the year produced outside New York. The play is the subject of a national documentary on harassment and suicide of GBLT youth (www.uglyducklings.org). She tours internationally, offering performances, lec- tures and workshops on lesbian theatre, survivor culture, and non-traditional roles for women. Her books and plays are available at her website, www.carolyngage.com.

Cello Speak: Exploring New Languages for Madness

BONFIRE MADIGAN SHIVE

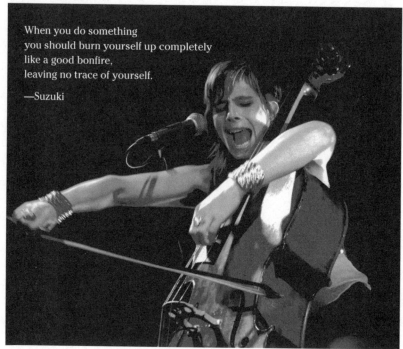

When you do something
you should burn yourself up completely
like a good bonfire,
leaving no trace of yourself.

—Suzuki

Nada Ngank / Memento - City of Women 2006

The Cello

I had a unique and magical childhood. My parents were involved in a counter culture scene living in teepees, raising goats, harvesting wild herbs for medicine and dumpster diving food. For a while, I even had a companion trail pony that lived outside our teepee! It was an incredible universe to grow up in, but sometimes it would stop being magical. My mom would go from being my punk hero, pissing in corporate parking lots, to not knowing who or where she was. I saw through her how people who create different realities were seriously persecuted. At the same time, I was beginning to experience alternate realities of my own—hearing voices and dealing with suicidal despair. My mother wasn't offered any language to understand or validate her world. I realized early on that I would need to create a language for myself in order to understand what I was experiencing. One that would allow me to navigate the "normal" world from within this mad, proud and creatively determined one I was born into.

I discovered the cello at "meet the instrument" day in fourth grade. We were taken into the cafeteria, which was filled with different instruments. As I was steered towards the flute, I remember asking, "What's that big violin behind the piano?" "It's called a cello." "*Cello.*" I remember the word in my mouth. It felt like home. I held it in my arms for the very first time. It was as big as me. I remember thinking, this was it: this was what I was going to do with my life—learn to speak with my new mysterious companion.

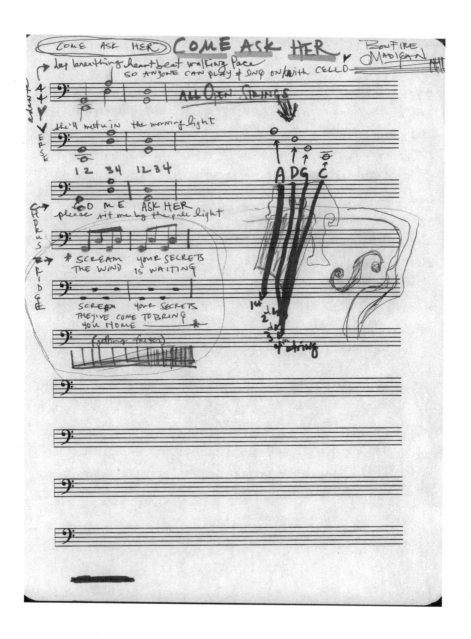

Invisible Friends

When you're young it's okay to invent your own realities. I've always had invisible friends myself. When I was really young, my mom made me a Raggedy Ann doll. This doll was my best friend. I'd put my clothes on her, and then I'd wear her clothes. I felt that we were reflections of one another.

Later, when things would get very volatile around my house, I created a similar friend. There were a lot of arguments and things breaking at the time, and I started thinking that there wasn't real love until there were dishes flying across the kitchen. There was a hole where the doorknob would hit the wall in my bedroom. After so long of the doorknob hitting the wall, I started thinking that all of that anger and frustration was to create access to another world. So I created a relationship to this sort of spirit that I felt lived in the wall, and thought that only that ferocious rage and love would bring it forward.

I called this spirit/dream character Whisper. I would talk to it by speaking into the doorknob hole in the middle of the night. And I thought Whisper really was there. There were times it would talk back to me. I told Whisper all the stuff I couldn't say to my dad or my sister. I'd say, "Whisper, Mom was called mentally ill. Is she going to be ok?" Any mention of the words "mental illness" was a big no-no in my family, it meant, "What—you want her to go away, you never want to see her again?" Saying these things to Whisper allowed me to express my fear. It was a profound coping mechanism. Later, with the cello, I created a similar companion by using sound to express things I could not verbally articulate.

Voices

As children, we're allowed to create alternate realities in order to deal with emotions we have a hard time expressing. However, as an adult, if you 'hear voices', you're immediately persecuted. One of my first adult experiences with hearing voices was a moment that saved my life. It was an intuitive, pre-cognitive intervention in a moment that could have proved fatal had I not listened. The voice wasn't telling me to do anything harmful: it just told me to keep my wits about me during a long road trip, and made me aware of my surroundings in a way I hadn't been before. Soon after, a group of men attacked my car in an empty parking lot threatening to rape and murder me. I was alert enough to lock the doors in time because I had listened to that voice. I realized instantly that this voice was there to help save my life.

The dominant culture tells us that these inner voices are scary and destructive, that they say, "Kill yourself." But the voices may be saying, "Become aware on a different level." That first experience made me aware of my inner life in a whole other way. I feel like it was a gift.

We live in a world that just wants to silence those voices, to medicate, to pathologize, and treat it as a psychotic episode that must be suppressed. I decided then that I could not allow my madness to be demeaned, criminalized and medicated from me. It was clear to me that moments of crisis, trauma or "breakdown" could also be opportunities for "breakthrough."

The Language of the Medical Profession

If I told a psychologist about hearing voices, I knew they'd give me a multiple personality disorder label. If I talked about having

thoughts of suicide, they'd give me another disorder, maybe clinical depression, and involuntarily commit me. At different times I likely would have been given many different psychiatric labels. Even though I was given the label, I don't subscribe to "I'm a bipolar person and I have an illness." The term "Mental Illness" has been marketed as a sexy way to make money off people's distress, despair and disempowerment.

Ironically, a lot of the self-destruction I feel in myself and see around me comes from feeling so helpless beneath these oppressive social systems that degrade us. My mother always feared the psychiatric hospitals. They gave her no empowerment. They just reinforced what she lacked, which tore away all of her self-worth. No one ever said to her, "Here's something you're brilliant at. Here's a valuable skill we appreciate and need from you." Often we degrade ourselves first so that the pain and shame of being cut down by someone else isn't as biting. "Let me do it first—I won't give you the satisfaction of having hurt me this way. The one thing I get to decide is how I experience this reality."

I wasn't given the label "mentally ill" until later in my twenties. At that point, I realized that everybody I loved and admired throughout my life had been steered in and out of jails or mental health facilities, silenced by constant fear of "symptoms," fearful of being given lifelong labels of being diseased or committing suicide because they couldn't get a hold of their mental gifts. I thought, "We must get a new language around what is going on here: the criminalizing of moods, of poverty, of altered states, of hearing voices, having visions, basically of all our freaky eccentric, proud devious ways that

CARING FOR MY MADNESS: #1 B4 MORE WHO LOVE!

WELLNESS/CRISIS PLAN

FOR WHEN I'M FEELING = TRIGGERS:

HELPLESS	JUDGED
ANGRY	PERSECUTED
OVERWHELMED	STAGNANT
HOPELESS	TARGETED
TRAPPED	MISUNDERSTOOD
LONELY	UNREASONABLE EXPECTATIONS
FAILURE	SELF LOATHING
RAGE	STUCK

HEALTHY OPPOSITES = ACTIVITIES TO DO INSTEAD:

CELLO	SAY I LOVE YOU
MUSIC	GO FOR WALK
SING	ROLLER-SKATE
SCREAM	MASTURBATE
WRITE LYRICS	HANG OUT WITH KIDS
CLEAN SPACE	PET CAT
MAKE (GOOD FOOD)	POSITIVE GRAFFITI
LONG BATH	PLAY!
WRITE LETTER	YOGA/STRETCHING
DRAW / PAINT	WATER PLANTS
DEEP BREATHING	READ / SLEEP
CALL SOMEONE (GET PERSPECTIVE)	

DBW - DAMN GLAD TO BE ALIVE =

NEXT STEPS:

1. TAKE A DEEP BREATHE. CONNECT WITH EARTH. GROUNDING
2. ASK DEFEATING THOUGHTS TO LEAVE
3. STOP!
4. ANOTHER DEEP BREATHE, STAY IN BODY
5. IDENTIFY FEELINGS
6. PRACTICE UNDERSTANDING VS FACTS OF SITUATION
7. WRITE FEELING DOWN FOR LATER
8. DO AN ACTIVITY IN SPITE OF FEELING = HEALTHY OPPOSITE
9. CHOOSE ACTIVITY
10. PAY ATTENTION/FOLLOW THRU w/ ACTIVITY
11. IF NOT WORKING CHOOSE ANOTHER ACTIVITY
12. CALL SOMEONE = 3AM ALLIES LIST — ICARUS ALLIES, BGS, JANE, TOMAS, MACHIKO
13. FOCUS ON BREATHE - 3 PARTS
14. FOCUS ON ACTIVITY
15. SLEEP IT OFF?!
16. EMERGENCY CONTACTS/CALL SOMEONE TO COME/BE WITH ME
17. STAY ALIVE! WITH MORE RADICAL LOVE!

do no harm." These things, in moments, represent profound coping mechanisms, survival skills and lifestyle illuminations that ask us to consider living in other ways not sanctioned by dominant society.

My Mad Coming Out

As I was coming to terms with my own experiences with extreme mood states, sensitivities, voices, and suicidal despair, I was touring as a new music composer and cellist. Since I was traveling so much, I constantly was shifting experiences, which made it hard to get a hold of my mental states. My band mates started calling me a "moody vampire." I realized then that I needed a plan to ground myself whenever I became overwhelmed.

My crisis/wellness plan came out of this. It is a little mad map I created for anytime I felt I was in an emotional crisis. I also called it "what to do when the negative feedback loop is saying that I should die." At the top, I list different hurtful emotions I may be feeling, like "helpless," "rage," or "unproductive." Below these, I have a list of healthy opposites I can do instead of staying in that emotion. I still accept the fact that I'm feeling that emotion, and that it has a right to exist, but instead of suppressing it and allowing it to dominate me, looking at my crisis plan allows me to name and validate my experience, while transferring the energy of that feeling into an activity that is healing. On the right hand side, there's a list of ways to follow through with the activity. It has simple directions like "Breathe" and "Relax," because sometimes just saying I'm going to do a healthy opposite isn't enough—sometimes I need it written down or even read aloud by someone else.

After I'd written my crisis plan, I realized that I had actually been writing around these themes for awhile in my work, and it was time to "come out" in relation to my own thoughts of suicide and mood extremes that often get people labeled "diseased" and shunned by their communities. I made copies of my crisis plan and called it "A BMad (Bonfire Madigan) Mental Health Tour Zine Workbook." I passed them out for free on tour, and started connecting with other people who experience similar issues.

Coming out like this allowed me to start forming a new language with others and with the "Deep Pressing End," which is what I like to call my own painful feelings instead of "Depression". There's magic in words, and instead of allowing people who haven't had these experiences to form the language around it, discussing it with other people who've dealt with these emotions has allowed us to claim ownership of the ways of living our lives and moving with them. Just changing "Depression" to "Deep Pressing End" allows me entry into my own understanding of what I'm experiencing, which allows me to take part in my own healing.

Another way of taking ownership of what I feel with words is by taking the issue that is making me feel suicidal, and giving it a name. I name it something like "Stuck in a Rut," "You're a Failure," "Unresponsive Lover," or "Rent is Due." Again, I still respect the feeling that it's happening, but by naming it, I'm able to identify it, talk to it, and make it part of the process of change. I can say, Okay, "You're a Failure," its been nice visiting, but it's time for you to go now because "You're a Success" is calling.

In this way, I acknowledge all sides of my experience and refuse

to damn my whole present self. We need to deal with all the parts of ourselves—habits, behaviors, rituals—on their own, instead of constantly attacking our core identity. Instead of insisting upon dramatic either/or understandings of wellness, we must accept that we are all in states of change. Striving for incremental change allows for sustainable self-healing, and gives us the ability to lessen the harm instead of trying (in vain) to eradicate it.

Change is good, necessary, and inevitable. Instead of there being one fixed reality, life is more of an identity continuum. Maybe suicide is really just wanting to change your identity as you are living it in this moment. We all have the opportunity and power to radically reinvent the person we think we are, or are told we have to be. I am on a journey of discovering who that is all the time.

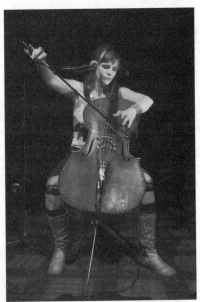

Nada Ngank / Memento - City of Women 2006

Mad Skywriting

I am changing my name
I am burning my past
I'm laying yesterday to rest at last
I am owning these actions
then setting them aflame
I'm not sorry for who I am
or who you wanted me to be

I am skywriting this survival
I am sending this survival in a bottle to the stars
here now—hear this now
I am not sorry for being here now
hear now
I am not sorry cuz I've made it here now
hear now
there's no apologizing for being here now
hear now
be not sorry because you are here now

plant your feet in the ground
then take a stand
we're all human beings while we're falling down
bent over backwards to grab your hand
we are all human beings while we are hitting the ground
existence should be enough
existence could have been enough
existence should have been enough
existence should be enough
for love
existence should be enough to be loved
existence is enough for love
love

Lyrics to Mad Skywriting first appeared on *Saddle the Bridge* from Kill Rock Stars Records.

Cello Speak

For the past hundred years, we have been living in an era of medicine and health where the body is a machine that you treat with surgery and drugs. Experiencing something "different" was a symptom that needed to be treated. But these so-called symptoms are part of us, instead of just cutting them off, exploring where they come from allows us to understand ourselves and our untapped capacities. In fact, each time I sit down with my cello, I learn something about myself. Sometimes when I start to make sound, I'm like, "What do you want to tell me today, Cellina, what are we feeling, where are we at?" And I let the sounds inform me.

A lot of people put feelings in their instruments that they can't express anywhere else. Recently, I had to bring my cello to an instrument repairman. He told me that once he received an instrument that was loaded with so much despair, he couldn't work on it. Grief, longing, lust, triumph, abandon and release—the cello even physically inhabits these expressions. Playing it is all about abandon, tension and release. It's just like what we go through in moods. We're all falling in love, getting our heart broken, our hopes squashed, our desires fueled or our dreams sustained, sometimes all at the same time! Why must we deny all these things? Why deny those hundreds of harmonics? I have learned that we must not.

A Mad Gifted Community

Rostropovich is one of my favorite virtuosic cellists. He knew that the sound was about a spiritual release. In 1989, he played at the Berlin Wall for free, encouraging people to tear it down. He used his

instrument not just for elite halls, but as a tool to confront fascism, hierarchy and oppression. I call this process "allowing yourself to be shaken so that you're changed, and through your transformation, you change the system." That's when we're actively participating in our own liberation.

Playing cello is my way of calling out to my fellow mad souls to come together and form our own understanding of mental health, self-care and community healing. By taking a very unorthodox approach to my instrument, I have gained a partner in creativity— a life-long companion in exploring life beyond text or the linear mind.

Music is an indigenous language. It's the heartbeat. A lullaby comes from every one of us in the womb, the heartbeat, and we feel it. That's the first meter and cadence, written in our first tissue of heart and eye. It's our connection to our universe and one another, connecting our individual understandings, sensitivities and struggles to a great collective moment. That is ultimately where the music comes from; it becomes that new language. I am living every day with the belief that the true rebellion of community is to pull our dreams out of each other in as many languages as we can find to describe them.

Bonfire Madigan Shive is a visionary cellist, vocalist, avant-pop composer, community organizer, performer, and touring musician with her own independently run record label MoonPuss music. Her work flows through the DIY art/activist movements from Riot Grrrl to Queercore to Chamber Punk and beyond. She is a founding collective member of The Icarus Project (theicarusproject.net), a voluntary mutual aid support network led by people living with experiences that are commonly labeled "mental illness." Visit her at bonfiremadigan.com.

no more crying

bell hooks

Growing up churched the old believers faced trouble by repeating the maxim "God will not give you more than you can bear." I heard them but to my child mind it was infinitely clear that plenty folk were given more than they could bear—burdens which shattered minds and broke hearts. Later in life I learned that trauma is just that: "more than anyone can bear." Even though we live in a culture where there is an industry focusing on trauma recovery—all manner of therapy, self-help strategies galore, an endless production of self-help books, the truth remains—that trauma is usually more than we can bear. Insightfully, in her important work *Trauma and Recovery* Judith Herman explains: "Traumatic events call into question basic human relationships. They breach the attachments of family, friendship, love, and community. They shatter the construction of the self that is formed and sustained in relation to others. They undermine the belief systems that give meaning to human experience. They vio-

late the victim's faith in a natural or divine order and cast the victim into a state of existential crisis." Trauma recovery is a protracted process: complete recovery is rare.

It is the difference between healing, being cured, and learning how to cope with a chronic painful condition so that it no longer endangers one's life. When trauma has been extreme most folks (and here I am only speaking of those among us who seek recovery) learn to constructively cope with trauma and its aftermath. We learn that there is pain that simply does not go away. And we learn that without critical vigilance that pain can be triggered in ways that are emotionally and spiritually life threatening. Importantly, survival is not enough recover enables one to thrive.

Many abuse survivors hone our strategic survival skills in childhood. More often than not those skills prove counter-productive when we attempt to use them in adult life. In my childhood the everyday hurts I suffered were mostly inflicted by verbal abuse. When I attempted to defend myself I would be described as difficult and more harshly as crazy. If it had not been for my intense passion for reading, I would not have learned to stand back from family and observe. I would not have developed a practice of detachment that empowered me to critically question and resist. Books brought into my life visions of family different from my own experience. And at times they brought into my life images of a shared fate, whether fact or fiction. Somewhere there were children experiencing all that I experienced, children deemed outcasts, weird, difficult, uncontrollable and those children managed to survive and every now and then to live happily ever after. Essentially

one had to learn how to persevere, to not become a victim of soul murder.

Understanding that I was not to blame for the pain and abuse inflicted on me helped me to survive. And that understanding came to me from books. From fairy tales to *Jane Eyre*, *Wuthering Heights*, *Little Women*, and a seemingly endless number of books, I learned that children were often the unjust targets of adult rage, frustration, and projection. Knowing that I was an unjust target did nothing to ease the depths of my pain yet it did give me strength to resist.

Emotionally, a survival strategy that aided me in my distress was the intense expression of grief, a conscious sorrow. I lived my child life in a constant state of mourning. Unlike many other hurt children I did not repress my grief. I cried out! To this day in my sleep I dream I hear my sisters yelling to mama, "make her stop crying!" Being the one excessively persecuted child in a family of seven children, I was an outsider, victimized and tormented by my parents and oftentimes by siblings. In our household crying was seen as a sign of weakness. Strong black females did not cry. No wonder as part of their exclusion of me from their family community, I was often taunted by the label "miss white girl." When I cried my family chose to identify my tears as signs of madness. Endlessly telling me that I was crazy, that I would end up in a mental institution where no one would visit me was their way to silence my cries. At times mama would declare: "If you don't stop all that crying I'll give you something to cry about." This was a warning that unleashed outburst of verbal and physical abuse was coming my way.

I found secret places where I could cry in peace, in dark closets,

or lying buried under enough covers so no one would hear. I could sit at my desk at school and cry. This continued expression of grief made public by intense crying spells gave voice to the depths of my suffering. I mourned for myself and for my family—for all of us caught in cycles of pain. Overwhelming sorrow that I was not able to stop the hurt—my own pain—the pain of other— surfaced at both traumatic moments and at those times when memories were triggered. My tears were a constant reminder that somewhere, something was very wrong.

For the most part my sibling either mocked and ridiculed me for crying or insisted that I be silenced. Now and then my brother would try to intervene if I was being unjustly punished or persecuted. He was the family clown. His humor could take attention away and diffuse potentially violent moments. In our household where crying was deemed a major sign of weakness no one comforted me. No one held me in their arms and told me everything would be all right. At my grandparents' house, Daddy Gus, mama's father, would hold my hand and quote scripture telling me "blessed are those that mourn for they shall be comforted." His was the soothing voice of hope, the enlightened witness Alice Miller writes about in *Banished Knowledge*, a "helpful witness" who "shares the child's perspective." Daddy Gus loved me. Against the portrait painted in my home that I was crazy and unlovable he offered a portrait of divine spirit in me that was redemptive, sharing that I was beloved and holy. He placed my grief in a spiritual context.

Teaching me to see grief as a way to learn compassion both towards my self and towards those who tormented me, Daddy Gus,

deacon of the church and wise elder, gave me permission to mourn scoffing at those who ridiculed me. In Henri Nouwen's meditation *The Return of the Prodigal Son* he explores the restorative power of grief explaining, "Grief asks me to allow the sins of the world—my own included—to pierce my heart and make me shed tears, many tears for them. . .When I consider the immense waywardness of god's children, our lust, our greed, our violence, our anger, our resentment, and when I look at them through the eyes of God's heart, I cannot but weep and cry out in grief. . .This grieving is praying. . .the discipline of the heart that sees the sin of the world, and knows itself to be the sorrowful price of freedom without which love cannot bloom." As a survivor of attempted soul murder I am retrospectively grateful for the grief that was the catalyst for constant tears. And the sadness that kept me feeling.

Many hurt children lose the capacity to feel. Disassociating they enter some numb place where the heart is hardened. They survive by repressing emotion. More often than not they survive physically by surrendering to soul murder. Emotionally, they accept death as the only way out, real or symbolic. Often I wanted to die. Often I had to cry out against the seduction of this longing, that voice saying "if only I were dead, the pain would end, there would be no more suffering, no more crying." Recovery for me has meant letting go of sorrow that overwhelms. I no longer need to daily release toxic pain by crying.

In *Out of Solitude* Henri Nouwen again places the experience of suffering in a spiritual context, sharing, "The first thing that Jesus

promises is suffering . . . Jesus changes our history from a random series of sad incidents and accidents into a constant opportunity for a change of heart. To wait patiently therefore means to allow our weeping and wailing to become the purifying preparation by which we are made ready to receive the joy which is promised to us." Certainly this is what Daddy Gus meant when he told me again and again that "one day my suffering would end." The journey through the vale of tears that transformed me from a childhood victim to a healthy loving selfhood was long and arduous. My grief did not end with childhood but it did end. Strategic mourning not only helped me resist it helped me to heal. In recovery sadness takes its place within a pantheon of many emotions the most powerful of which is the experience of sustained and ecstatic joy.

bell hooks is a feminist and social activist. Her writing focuses on the interconnectivity of race, class, and gender, and their ability to produce and perpetuate systems of oppression and domination. Her books include *Ain't I A Woman: Black Women and Feminism Feminist, Theory: From Margin to Center, Where We Stand: Class Matters, We Real Cool: Black Men and Masculinity*, and *Communion: The Female Search for Love.*

Self-Portraits

NAN GOLDIN

"My work has been about making a record of my life that no one can revise. I photograph myself in times of trouble or change in order to find the ground to stand on in the change. You get displaced, and then taking self-portraits becomes a way of hanging onto yourself."
—Nan Goldin

Self portrait in blue bathroom, London 1980

Nan one month after being battered, 1984

Nan at her bottom - Bowery, 1988

Self-portrait on the train, New Haven to Boston, 1992

Nan Goldin began taking black-and-white photographs of her friends in the transvestite community of Boston in the early 70s and had her first solo show at Project, Inc. in Boston in 1973. Her numerous solo exhibitions include a mid-career retrospective at the Whitney Museum of American Art (1996) and *Le Feu Follet*, a traveling retrospective organized by the Centre Georges Pompidou in Paris (2001). In 1995, she made a film for the BBC, *I'll Be Your Mirror*, with Edmund Coulthard and Ric Colon. Goldin has received the Englehard Award from the Institute of Contemporary Art in Boston (1986), the Photographic Book Prize of the Year from Les Rencontres d'Arles (1987), the Camera Austria Prize for Contemporary Photography (1989), the Mother Jones Documentary Photography Award (1990), the Louis Comfort Tiffany Foundation Award (1991), the Hasselblad award (2007), and many others. She continues to exhibit widely and is represented by the agents of the Matthew Marks Gallery, New York.

All images © Nan Goldin, courtesy of the artist and Matthew Marks Gallery, New York.

Silent Body, Speaking Body

ANONYMOUS

It's my first month teaching dance at this school and every day is a slow victory, a bumbling trial-and-error of finding my place amidst the tide of teenagers. It is a balancing act, to know myself and know my students, to figure out what to give them and how to guide. In my last class of the day, an awkward, too skinny girl's shirt slips up over her stomach during warm-up. On the skin revealed, I notice cuts, the red lines carved below her belly button, sharp angles forming a word. The moment interrupts me; I am jarred into recognition. She catches my eye; she knows I've seen it. The words tumble out of my mouth before I can choose them, "I have to speak to you after class." Her face reddens, her eyes shift away. She asks to go to the bathroom. "Okay . . . quickly." I imagine what she is doing while stuck in the small bathroom stall. Looking at it? Picking at scabs? I remember this: the moment of being seen, the terror and the relief.

After class, she stands by my desk while I sit looking up at her. She seems impossibly tall.

"I want you to answer this honestly: Are you cutting yourself?" (Already, I feel lost)

"No." (The answer is short, a wall she builds around herself)

"Then what's on your stomach?" (I don't want to be confrontational)

"Notes for a test." (As if cheating wasn't bad)

"Can you show me then?" (I wonder if this is okay)

"No!" (Her heart is speeding)

"I'm going to ask again, and be honest. Are you cutting yourself?"

"NO." (Now she's angry)

I pause. I am not going to win. She will not let me in.

"I want you to think about all the adults in your life. Think if there's anyone you can talk to about this. Cutting doesn't deal with our feelings. It only makes us avoid them, and that doesn't help us with them. It can also lead us to think of or try killing ourselves." I groan inside. I sound like a Public Service Announcement. I want to sound like myself. I want to tell her how much I know about cutting, about the way skin breaks apart and shows the mess inside us, about the grey fog of panic that evaporates like steam as the marks are made, about when I was thirteen. But there are two of me: the one who has been her and wants to tell her how I changed, and the teacher who can only say these words, sanitizing my experience into a script to be read.

"Okay." She leaves the room in a huff.

It's me in the tiny bathroom stall, staring at my arm. My stomach

twists; chest is tight. When I find myself tangled in my life, I want to cut my way out of it. There's a sliver of shame that I am even imagining cutting, the quick emptying of feeling from my body. I still want to, after all this time. It's like a lost lover who doesn't leave the edges of the heart. It's not the action of cutting I find so disturbing; it's the persistence of the desire, the need.

I can't remember the first time. I remember this: when I was eleven I was suicidal. I took out a knife and wrote a note. The feelings were real, the intention perhaps less so. It's the feeling that remains significant, an ocean-sized despair, claustrophobia, and hurt, like my whole life was a blue-stained bruise. I am not sure why I hurt so much, and I'm not sure it matters why. My family was intact, we had money. I went to good schools and did well in them. I had friends, I had talent, I was ambitious. But my life was divided in two: the outside which looked good, and the inside where I was suffocating. I couldn't make sense of them, how they could exist together. Cutting aligned the mismatched reality, brought the chaos to surface and appeared to control it. I could see what I felt by looking at the red lines and scratches. The curiosity lay in whether or not other people would see. And if they saw, would they respond? Would they see what I needed them to see?

My mom's eyes catch the red lines on my arm, sliced through a cigarette burn I gave myself. "What's that?" she asks. "Nothing," I say. She doesn't press any further and turns away. In her silence, I am terrified. What more would I have to do to get her to keep asking? What courage would she need to find to witness both sides of me?

What is so hard about not cutting is that cutting worked. It made

the invisible story exist on the outside. Unlike anything else destructive I ever did, it just doesn't seem to hurt that much. The damage always heals. The body is so resilient.

Maybe it is the body's resiliency that drew me to dancing. When I was six, I would put on records in the living room and spin my body around, jump into the air, carve shapes and sculptures with my muscles and bones. Dance could pull what was inside out, it made me seen, it made me feel real. I asked my parents if I could take dance classes, and they found a small, funky dance school at an old soap factory in the industrial zone of the city. It was perfect for me. I would not have made it in ballet or jazz classes, emphasizing perfection and prettiness. I was already making dances and showing them in the living room, thinking in choreography, mapping movement into time and space.

Dance did what cutting did, sort of. My body found control and then abandoned it to fall, dive, fly. Dance brought my inside story out and made it into movement, instead of marks on my skin. With both, I wanted someone to see the hurt I could not understand and could not handle. But I could not pick dance over cutting; I could not stop hurting myself, hating myself. I carved deeper divides between my two lives. I had a life where my body was a tool, my instrument, where I made dances about the parts of life where my skin felt too thin. And I had a life where my body became a canvas for my rage, my inability to be in the world, an emptiness I could not avoid, rub out, or escape.

I'm in the doctor's office. She notices four red lines on my arm. She asks me something about them, I can't remember what. She asks me if

I have been raped. I say yes. She asks me if I want to get help, see a therapist. I shrug. Afterwards, I snort lines off the toilet seat in her bathroom. Everything is blurry and I have a panicked feeling like I can't breathe. The bathroom seems very clean and very safe. It is gold and white. Somehow I am aware that I am barely able to be at all.

Space grew between my two lives. One where I danced, another where I cut. One where I was responsible, another where I was drank too much. One where I was a feminist, another where I binged on food and starved myself. One where I accepted my sexuality, another where I was had sex with people I didn't want to. One I could control, one I couldn't. One where I wanted help. Another where I didn't. I endured injury after injury and missed shows and opportunities. I became raw from having no skin and no edges, no truth I could withstand.

The awkward student begins to find a passion for dance. She comes to class excited to move, to create her own idiosyncratic dances about what she believes in, about war and peace, about everything and nothing, ideas large and small. We don't talk about cutting again. I see white lines on her arms—old cuts. I promise to report anything new to the school administration, but I haven't seen anything. I know too well that doesn't mean it isn't there. I hear slivers about her thirteen-year-old life, about parties and dates, friends and high school. Sometimes I am afraid as I listen, afraid that she will be hurt too much by the situations she creates. She seems to be continually in danger, pushing the boundaries around her. But even as she struggles, she's finding a joy in dance. The school's annual dance concert is approaching. She is performing in three pieces, uniquely leading other dancers

in each one. I don't think her life is painless. But I see her discovering a love for something bigger than her. She says to me one day, "I think I'll go get my BFA in Dance, and then go back to school to become a teacher." I hope one day she will quietly lead her students, and look at her arms without longing to mark her skin anymore.

It's after midnight. I had only two drinks at the party. I am in the car going home. I know I want to die. I go home and take out the same knife. Once again, the feelings are real, the intention is questionable. I call my girlfriend. She calls my parents. They come downstairs. They are angry. Later I will realize they were scared. I can say only two things: " I want to die" and "take me to the hospital." In the car, my hurting knows someone has seen it. I almost feel better, I want to say "Stop, it's okay, let's just go home." I don't say it. At the hospital, they decide to admit me to the psychiatric unit. The next day I wake up, completely empty, almost numb, but the emptiness is louder than numbness. I don't know it, but from this emptiness a new life will begin. One life where I am not in pieces. I only want this life because I want to dance.

For all the failed cases that come and go through psychiatric hospitals, I was lucky. I wanted something enough to want to change. I didn't know I would learn to change everything. I would learn to start talking instead of hoping people could read my mind or my body. I would learn to look at the world from a different perspective, to see more of the joy and less of the suffering, I would learn to create a foundation that anchored me. My learning was slow, a slow dance. I stumbled many times, falling back into my small patterns of fear and gradually breaking away from them. In dance, I knew how to try and fail and try again. I knew vulnerability, to share the heaviness inside

me, to trust that even if I fell apart, I could be mended. I knew I didn't know everything—to have faith and be humble. Dance was my constant partner, the guidepost for what I was seeking. It became more than just why I lived—it was the way in which I lived.

After spring break, my student is not in class. The kids mumble something about her being sick again. I pass her homeroom teacher in the hallway, he says, "it's complicated." Turns out she was hospitalized for psychological problems. When she comes back to school three weeks later, she is subdued. Her edginess tapered off, her mood quiet like a dark pond at dusk. It was the hospital that was a crossroads for me, but she has not turned onto any path out. She sulks, staring at her stomach in the dance room mirror. I feel like I am standing on the outside of a glass bubble. The best way to help her would be to tell her my story. But the school rules, and the strange mandate of teacher-student relations, keep my mouth shut and a line dividing what I know and what I tell.

Is this the silence of my mother? Maybe. But it is not that I am afraid to see her pain, it is that I am afraid to speak. As much as I have repaired the fragments of me, I'm still forced to split and divide, to keep the inside in, to dissociate from my history. The balancing act is fragile. I hold onto this small hope: that I can tell my story in ways beyond words, in action, in movement, that what and how I teach can make up for what I cannot say.

Anonymous is a Brooklyn-based dancer and choreographer. She uses dance to explore the ways in which large social forces affect the individual life, and to bridge cultural divides and support conflict resolution.

Art as Prayer

KATE BORNSTEIN

I'm a sucker for good mysteries, the ones that religions are *supposed* to help you solve: like who are we, where did we come from, and what the fuck *is* this universe we live in? Or how about the truly cool mysteries, like what is it with this edge of depression I've spent my life teetering on? And then there's my special childhood and young adult mystery: I was a boy who wanted to be girl. What religion/deity/philosophy/morality/ethical code was out there that made room for *me*, gave *me* some shot at relief through prayer?

I was a fat, awkward adolescent boy who wanted to be a sexy, graceful teenage girl. I hated my body, so I spent as little time as I could connected to it. I cut on my body so I could return to it. When I cut, I could feel *something*, better than nothing. It was temporary relief. Then I taught myself how to stop eating,

When you're hungry, your body is hardwired to say, "Eat, you idiot!" When you're anoretic, you say to your body, "Fuck you—I'm stronger." It's a kick. It's a high, bringing yourself close to death like that. I lost about thirty pounds in one month, starving myself to 60s

supermodel skinny. It's an easy thing to do, and it's stupid and it's deadly but I did it because—what the fuck—I didn't like the fat body I had. Early on in my life, I lost the ability to ever see myself as *not* fat.

I slashed on my body and worshiped my hunger all through high school. By the time I got to college, the cutting and starving were no longer working and I added drugs to the mix. But even drugs stopped working eventually, and there came a point when I just wanted to die rather than live the freak life that seemed to be my destiny.

I turned to religion to help me with my very personal mysteries of sexuality and gender. I dove into a number of religious paths in turn: conservative Judaism, Amish Christianity, radical Kabbalah, the Bahai faith, and a number of pagan hippie communes. Each of those paths wanted me to be the strapping young man I was born to be. Then I found Scientology.

Scientology wasn't a religion when I joined in 1970. They called themselves an applied religious philosophy. They taught me that I'm not my body, I'm not my mind, I'm a spiritual being, and spiritual beings have no gender. Ha! And it worked! The regimen and therapeutic techniques of Scientology gave me the first moments in my life when I wasn't obsessed with being a girl. I felt *normal* for brief moments at a time. But even though Scientology teaches that we are spiritual beings that have no gender, anything that's vaguely off kilter in sex or gender is enough to mark a person as evil. Inevitably, I'd crash headlong back into my sinful, perverted transsexual dreams. Over and over… I'd swing between *happy to fit in,* and *miserable with the truth of my desire.*

I couldn't talk about it with other Scientologists, so I was virtually forbidden to use words to express the complexity that was *me*. I decided to try visual art in an attempt to communicate and release my inexplicable, conflicting emotions. I taught myself to draw, illustrating Scientology's "emotional tone scale," a chart of emotions intended to classify how spiritually alive or dead a person is. Every free moment I had, I'd sit hunched over a book of blank pages. I drew myself in each of over fifty simple but profound emotions. None of it was pretty.

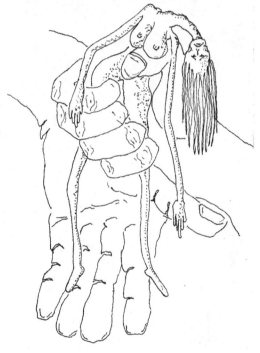

Victim

I drew myself completely helpless, clutched tight by some giant. No bones to fight back with.

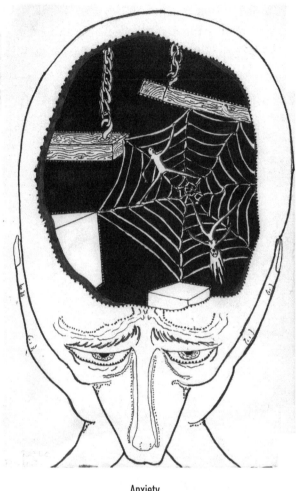

Anxiety

A girl body/boy body on a spider web. I thought that was a pretty heavy-handed way to express the anxi-
ety that accompanied the denial of my self, but NO ONE FUCKING GOT IT. So I kept on drawing.

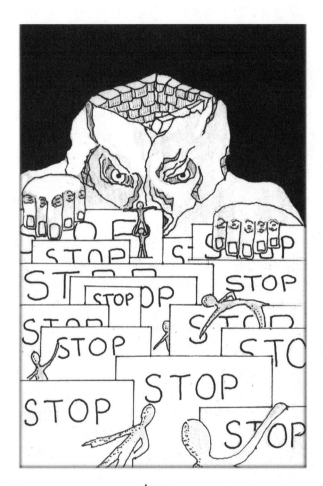

Anger

There's a Scientology principle—some of their principles are pretty cool—that says that the only thing angry people want to do is stop things. The brick guy in this picture is my father. I'm climbing over all his attempts to stop me: "Stop acting like a faggot," "Stop being a little fatty," "Stop being so girly." I heard, "Stop Being."

It was through drawing that I was finally able to express my desires. When people police our desires, they degrade our identities. When our identities don't match up with the expectations of those we've given power over our lives, then our own power goes down the tubes. Identity, desire and power are three interlocked aspects of life that make living more or less worthwhile.

Desire in particular has a bad rep in most religions. In Judaism, there's a commandment against it. You mustn't covet they neighbor's anything. You must not ever feel jealous. You must not ever *want*. That's bad, bad, bad!

Well, I don't know about you, but I've *never* been able to successfully ignore or negate desire. That just makes my desire *stronger*. Like masturbation. Early on I learned that was a bad thing to do. "No, no, no I won't jerk off. Oh my god, but I *have* to jerk off, I have to!" And then, "Oh no, here I am, jerking off."

When you fulfill a desire you had the intention *not* to indulge, you can't enjoy it. You failed . . . again. It's taken me a lifetime to learn that as long as my desires don't lead me to be mean to someone else, I'm okay. You can desire anything. Anything. And use that to propel you to the next part of your life.

Wanting can be delicious. *Wanting* can propel you. *Wanting* can give you motivation. And of course, wanting too much can destroy you. It can make you greedy. When your desire is impossible to achieve—or maybe it's just a bad idea—then the challenge becomes: how do you find just enough good in the wanting itself, so it doesn't consume you?

Nowadays if I don't have something I want, I figure out how I would

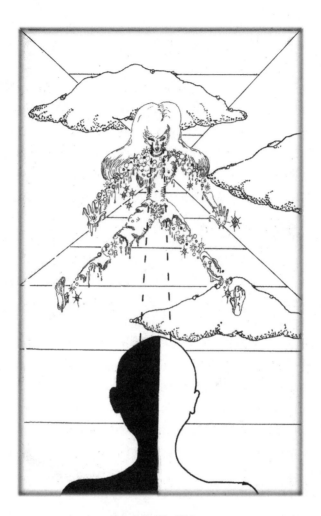

Materialize Me, Mister

Like most western religions, everything in Scientology is black and white, right or wrong. That's all you're allowed to want: this or that. I wanted guidelines, but I wanted more than either/or. I wanted the sparkling imagination that had kept me alive up to that point in my life. I drew my sparkling imagination as female.

feel if I *did* have what I desire. Then I figure out what *else* might let me feel that way or close to it. We can shift our desire and focus it anew, shift and refocus, shift and refocus. We can analyze our desires. We can use our minds, not just our genitals and our heart, and when we bring all three of those together into the real world, desire becomes fuel. Desire becomes motivation to go on living.

In retrospect, that's how I've lived my life. I went through a gender change, which a lot of people would call self-destructive behavior. I mean—shit. That's heavy surgery. You don't go back. Did I get what I wanted? No! No, I wanted to be a woman. And it didn't work! So I re-tooled my desire and redefined. Now I've got this body—a body I'm learning to love and have fun with—and what does that make me? That was a wonderful puzzle once I got past the horrible sadness of it, and that puzzle has kept me going for decades.

Cutting, starving yourself, drugging, drinking... these are all rituals some of us develop in order to deal with pain. Each of these solutions to pain is in itself painful, so each solution/ritual contains a very personal lesson on how to handle the experience of pain.

Pain itself is nothing scary. It's the *surprise* of pain—the helplessness in the face of some pain—that can debilitate people. I'm sixty years old as I'm writing this. My body is starting to act and feel old. There's a new pain to feel every day, or a stronger degree of some older pain. Doing this "self-destructive" shit is keeping me in good spirits with the aches and pains—listen to me, old fart that I am!—I now have. I know what to do with pain. I know how to channel it. I can send it into my heart to make my heart feel all warm. I can set my pain to trigger a good cry, which I don't let myself do often

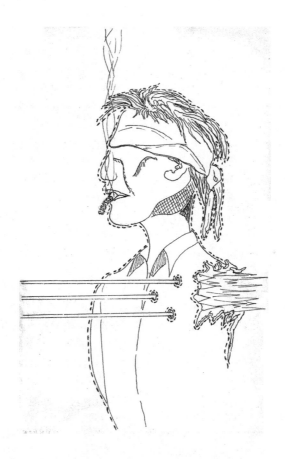

Numb

The space I occupied surrounded—but did not include—my body. I never felt comfortable in my body and so it was always a binary to me: me versus my body. Bullets could pass through me, and I couldn't feel them because I didn't feel my body anyway. Nothing penetrated my heart that I could feel. Except cutting. The cutting I could feel. That got through the numbness.

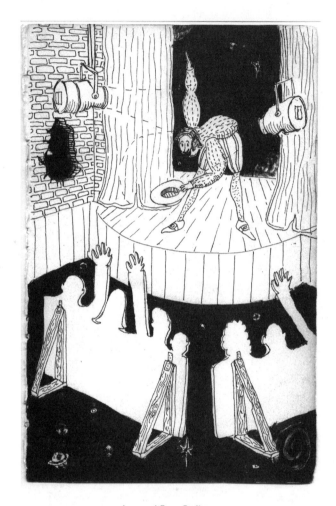

Approval From Bodies

Acting has always been a dream for me. I've always loved acting, and it's what I majored in in college. was a scene designer. I've built scenery, and I know how to make things that are fake look real. This just gave me a tickle, to think of myself playing for a cheering audience—and all they are are cardboard cutouts.

enough. Am I advocating self-inflicted pain? Yeah. Yeah, I am. Yes, it can get out of hand, and become its own obsession. But *any* ritual can get out of hand and become its own obsession. Rituals call for a great degree of spiritual and physical strength so as to conduct them in moderation.

Kneeling in prayer, sitting in meditation, taking peyote, even fucking your brains out can be a spiritual or religious practice if you do it consciously and with love. During my time as a Scientologist, it was the act of drawing myself that became my spiritual ritual. It was my own way of confronting my life's great mysteries. By drawing myself in dozens of negative emotions, I exorcised my demons—got 'em out there in my own clear sight. Confronting my demons gave me a reason to live while I figured out what the fuck I was. I'd finally found a way to communicate the inexplicable, conflicting emotions I was feeling.

The Scientologists I showed these drawings to never said anything in response to the content. I didn't care. I kept drawing. When the opportunity arose for me to leave Scientology, I snapped at it. That was about twenty-five years ago. Today? I don't draw much any more, but art is still my path to the spiritual. It's the only religious/spiritual path that welcomes me unconditionally. Art names me out loud. And art says to me, weird fuck that I am, I belong. I'm an artist.

Kate Bornstein is an author, gender theorist, and performance artist whose books are taught in colleges and universities around the world. Assigned one gender at birth, but now living as something else entirely, Kate identifies as neither man nor woman. She is the author of *My Gender Workbook, Gender Outlaw: On Men, Women and The Rest of Us, Nearly Roadkill: An Infobahn Erotic Thriller* (with Caitlin Sullivan), and *Hello, Cruel World: 101 Alternatives to Suicide for Teens, Freaks and Other Outlaws.* She is currently working on her upcoming memoir, *Kate Bornstein is a Queer and Pleasant Danger.*

Live Through That?!

BY EILEEN MYLES

I just want to be frank about what you will be really living through. You'll be living through flossing. Years of it, both in the mirror and away from it, both with girlfriends and alone. Girlfriends will be really excited that you floss your teeth, because they *should* and they think it's really inspiring that you do that and they will ask you if they can do it with you because it's easier that way, bumping their hips and thighs against you while you keep peering at yourself under the shitty bathroom light. They will even talk glowingly over drinks with their friends about the really diligent way you have of flossing and then the little brushes and even how you rinse and you'll look at their friends who look kind of weirded out and you'll be thinking you're just making me sound really old. I mean why do you think I floss my teeth for like fifteen minutes every night. My father lost his teeth at 40 and then he died at 44. Before I decided I also wanted to live I was utterly convinced that I would never lose my teeth and I have had tooth loosening and tooth loss dreams all my life, so in my twenties when I had never gone to therapy I decided that I would

always privilege the dentist over the therapist and that I was really getting a two-in-one service when I went to the dentist but still when I drank I would often pass out before I could floss. Then I stopped drinking. I found myself in my thirties leaning into the mirror one night cleaning away and I thought: fuck, is this what I lived for—to floss.

Well, yeah. I mean I don't know about anyone else but when I found myself at the age of 33 no longer spending the majority of my day getting sort of hammered I was to say the least perplexed. I never thought I wanted to DIE. That was not the point of my constant drinking. It wasn't a thought at all. Because there was such a thing as drunkenness, I aspired to it. I took it, it was there. Moderate friends would wince and even suggest I was "self-destructive" but that didn't sound right to me. Things would happen, that's all. I didn't mean them to be. It was surrounding circumstances—to alcoholism. Which was what my entire family life was too. My father didn't mean to make me watch him die. It just happened.

But this next act, the living, this was conscious. This was a choice. Or that's what I grappled with for a very long time. Do I want this. Being sober made me want to die. Cause I was swarming with feelings. About being a dyke. About being poor. About aging. About my inability to connect. About what a great poet I was, but what if, I don't know, first what if I can't write anymore, then what if no one will publish my work. None of these worries are particularly interesting or unique but I found myself in a state of endless worry. And who is this who can't turn the faucet of anxiety off with a drink or a drug. And yet I had a simple urge to preserve what I've got.

To tell you the truth if I am feeling ANXIOUS at night I sometimes think it's a good idea to go to bed without brushing my teeth. No face washing, nothing. It feels kind of wild. And I've slept with women and I've been friends with people who have shared that their secret decadence is the occasional tumble into the sack without brushing or flossing. So I do that too. But you know what, it's actually more interesting to floss. Because I face my face, myself, and I spend about seven minutes—first flossing, then the little brushes, then brushing the backs of the four molars, then the insides of up and down, then the front and the sides on the outside. I examine my gums. And uncannily at some point during this ritual I begin to feel better. It's like washing my car, and I never wash my car. It's the most intimate expression of care I know. And if I don't do it my teeth hurt the next day. Because get this: when you age your teeth spread a little so food gets caught in the cracks and if you have bone decay (and I do) the food gets jammed down there and almost instantly it produces pain. And miraculously though that pain produces panic and I begin to fear I will lose a tooth what actually happens is after I do a really good flossing and brushing the next night and maybe a little gargling (with peroxide which is really kind of a trip—your mouth gets sudsy and greasy! Don't worry. It goes away) the pain subsides. And I did it. Me! To tell you the truth, good tooth care is more like repairing a bike, which I also can't do. Okay so in all these years of tooth care some other things have happened, and I mean I have a mouth full of caps. I have fallen, and teeth have cracked of their own accord—well usually I bit a cherry pit, or a date. Or a kernel of corn, or a chicken bone—snap! A tooth cracks and you have just spent a thousand

bucks. So my mouth is full of these perfectly stained off-white piano keys that I meticulously clean every night. But still in all these years of care, through a squadron of dentists—all in New York and in New York still—I will not go to a California dentist. I'm not having it. All of the dentists have said for years—one day you're going to have to go to a periodontist. That seemed like the end. Yet my mother who is in her 80s and has ALL HER TEETH, she has gone to a periodontist. How was it, Mom. Awful she says. But then I imagine her biting into some food. We are usually eating when we talk and our love of food is certainly part of the issue here. Biting and eating, that's the story. Luckily when the day came—and really the day comes when you have the money—I began to explore going to a periodontist. I've gone several rounds of meet and greets and one guy in La Jolla was a monster. He made an obscene video of me with my lips pulled back and the damage was revealed in some fashion that was worse than the most humiliating pornography, worse than dead, and even when he was giving me the instructions to get my lips and jaw into the horrifying poses, he said—what did he say—good girl, or that a girl, something that sounded like I was an animal. And it was going to cost thousands of dollars. So much money. And he would be pulling. And restoring. I would have a mouth full of living, false, not "teeth gone" but something cold. This is kind of the end of my story or the beginning of the second act or maybe the third because I did something I'd never done before. I am not middle class. I don't have sharp perceptions about personal investment and bourgeois self-esteem, or I didn't then. But I had heard about this thing which is getting a second opinion. I don't even know how I approached it. I guess I

<u>went</u> to my dentist in New York, who I love, Michael Chang on 2nd Avenue across from the movie theater. I had another dentist before Michael Chang in the exact same location. It was Chuck. And he was great too. And he sold Michael Chang his practice. So I stayed with the building and the view from that particular dental chair. I allowed myself to be part of someone's practice that was sold. I am trying to give you sort of an extended picture of what I am living through. Michael Chang recommended another man, Michael Lanzetta.

I will only say that I enjoy these men and I trust them—with my mouth and my body. Incidentally I am 57. I just want to say something different has happened <u>about living</u> in the past few years. Not only am I not "self-destructive" nor am I ambivalent about wanting to live, nor am I unaware that this, all the time I've spent telling you about toothbrushing, this is actually <u>my life</u>, my time. One's life is literally that, their duration. And I've seen friends die young, much younger than me, and they keep dying my friends and one day I will too. And how I feel right now about that is a little sad because I want to live so much and have all my time and do so many things. So I have to attend to the thing in front of me because if I am not focused I can get overwhelmed by my desire to do everything still, yet as they say the clock is ticking and I won't get to it all, I can't. And the impossibility of that choice, of the <u>everything</u> when I was young, that choice made me a poet because I could have some purchase on everything and do a little bit of it all day. And it's essentially the same now and I've made the same choice again, when I decided to do what's in front of me but I probably can do other things too and I will. I just don't want to talk about them here. So Dr. Lanzetta was rec-

ommended to me by Dr. Chang and he quoted me a price like quarter of the animal doctor in La Jolla, and he was much less invasive in his plan and I was impressed that I had held out for something simpler and more comfortable. It was a unique choice in my life. To hold out, as if I could be like that. To trust my own, no, I think I'll wait. So in the face of the mountain of time I've lived, and in the eye of the mystery of what remains I feel quietly smart and open my mouth widely and slowly tonight and I brush. I examine, I grin. I'm a mechanic now, doctor, friend. I grin like a skull, but it's cool. That skull is my friend.

Eileen Myles is the author of more than twenty books, plays, libretti, performances, *Sorry Tree* being her latest (poems). She's a New Yorker living in SoCal since 2002, where she's a professor at UCSD. Everything changing again in 2008. Keep it green.

Resources

Suicide Prevention

National Suicide Hotline: www.hopeline.com,
1-800-SUICIDE (784-2433)

The National Suicide Hotline is a toll-free, confidential hotline for people in emotional distress or suicidal crisis. Callers gain access to immediate crisis counseling and information and referrals to local resources.

The Trevor Project: www.thetrevorproject.org, 1-866-4-U-TREVOR

The Trevor Project operates the nation's only 24/7 suicide and crisis prevention helpline for gay and questioning youth.

Rita Project: www.ritaproject.org, 1-866-775-RITA

Mission Rita (Sanskrit for Truth) is a global movement to stop suicide and to celebrate life. Rita Project is a non-profit organization devoted to using the arts to help survivors of suicide connect with the power of creation, and, in doing so, foster transformation.

Yellow Ribbon Prevention Program: www.yellowribbon.org,
1-800-273-TALK (8255)

Yellow Ribbon is a community-based program using a universal public health approach. This program empowers and educates professionals, adults and youth. They run a 24/7 hotline.

United States Suicide Hotline: 1-800-SUICIDE (784-2433),
TDD 1-800-799-4889, Youth Crisis Hotline 1-800-448-4663

Rape/Incest

Rape, Abuse & Incest National Network (RAINN):
www.rainn.org, 1-800-656-HOPE

The nation's largest anti-sexual assault organization. RAINN includes a listing of local crisis centers on their website and runs a toll-free and confidential National Sexual Assault Online Hotline.

Mujeres Latinas en Acción: www.mujereslatinasenaccion.org,
1-312-738-5358

This bilingual/bicultural agency seeks to empower women, their families, and youth to become self-reliant and improve the quality of their lives. They run a crisis line for victims of domestic violence and sexual assault.

After Silence: www.aftersilence.org

This nonprofit organization runs a message board and chat room for rape, sexual assault, and sexual abuse survivors. Their mission

is to support, empower, validate, and educate survivors, as well as their families and supporters.

United States Sexual Assault Hotline: 1-800-656-HOPE (4673)

Domestic Violence/Violence Against Women

National Domestic Violence Hotline: www.ndvh.org,
1-800-799-SAFE (7233), TDD 1-800-787-3224,
Spanish Language 1-800-942-6908

A project of the Texas Council on Family Violence, the National Domestic Violence Hotline is open year-round, 24/7. The staff speaks English and Spanish, and translators are available for 129 other languages. They offer crisis intervention, referrals to domestic violence and other emergency shelters and programs, as well as information and support.

National Coalition Against Domestic Violence: www.ncadv.org

The Mission of NCADV is to organize for collective power by advancing transformative work, thinking and leadership of communities and individuals working to end the violence in our lives.

Love is Not Abuse: www.loveisnotabuse.com

The Love Is Not Abuse program provides information and tools for people to learn more about the issue and find out how they can help end this epidemic. They run a teen dating abuse hotline at 1-866-331-9474 or TDD 1-866-331-8453.

Stop Abuse for Everyone: www.safe4all.org

SAFE is a human rights organization that provides services, publications, and training to serve those who typically fall between the cracks of domestic violence services: straight men, gays and lesbians, teens, and the elderly. They run a support and discussion forum on their website.

National Child Abuse Hotline: 1-800-4-A-CHILD (422-4453)

Mental Health

Mental Health America: www.nmha.org, 1-800-273-TALK (8255)

The country's leading nonprofit dedicated to helping people live healthier lives. They run a crisis hotline.

National Mental Health Information Center:
http://mentalhealth.samhsa.gov/

Their website offers a services locator online that can help find mental health services in your area.

The Icarus Project: www.theicarusproject.net

A radical mental health website community, support network of local groups, and media project created by and for people struggling with bipolar disorder and other dangerous gifts commonly labeled as "mental illnesses."

Mind Freedom: www.mindfreedom.org, 1-877-MAD-PRIDe (7743)

MFI is an independent nonprofit coalition defending human rights in the mental health system.

Freedom Center: www.freedom-center.org

Freedom Center is an alternative support and activism community run by and for people labeled with severe "mental disorders."

Pacifica syndicated Madness Radio: www.madnessradio.net

Wednesdays 6-7pm EDT on Pacifica Affiliate Valley Free Radio WXOJ-LPFM and south-central Alaska's KWMD in Kasilof. Co-produced by Freedom Center and the Icarus Project. Listen live at www.valleyfreeradio.org

Cutting/Self-Abuse

SAFE (Self Abuse Finally Ends) Alternatives Program: www.selfinjury.com, 1-800-DONT CUT (366-8288)

A nationally recognized treatment approach, professional network, and educational resource base, committed to helping you and others achieve an end to self-injurious behavior.

The Trichotillomania Learning Center: www.trich.org, 831-457-1004

TLC is a nonprofit resource for compulsive hair-pullers and skin-pickers, their families and friends, and medical and mental health professionals.

Eating Disorders

National Eating Disorders Association:

www.nationaleatingdisorders.org, 1-800-931-2237

NEDA is the largest nonprofit organization in the United States working to prevent eating disorders and provide treatment referrals to those suffering from anorexia, bulimia and binge eating disorder and those concerned with body image and weight issues.

Anorexia and Bulimia Webring:

http://t.webring.com/hub?ring=bulimarexia

The webring provides links to supportive online communities where you can talk about eating disorders and connect with others.

Overeaters Anonymous: www.oa.org

Overeaters Anonymous is a Fellowship of individuals who, through shared experience, strength and hope, are recovering from compulsive overeating.

AdiosBarbie.com: www.adiosbarbie.com

A one-stop body shop, where women and men of all cultures and sizes can learn about their bodies, and feel proud and comfortable in their natural shapes, sizes, and colors.

Alcohol and Drug Abuse

National Alcohol and Substance Abuse Information Center:
www.addictioncareoptions.com, 1-800-784-6776

NASAIC is an addiction recovery website and call center. You may chat live online, or call their 24/7 hotline.

Alcoholics Anonymous: www.alcoholicsanonymous.org

Alcoholics Anonymous is a fellowship of men and women who share their experience, strength and hope with each other that they may solve their common problem and help others to recover from alcoholism.

Harm Reduction Coalition: www.harmreduction.org

A national advocacy and capacity-building organization that promotes the health and dignity of individuals and communities impacted by drug use. HRC advances policies and programs that help people address the adverse effects of drug use including overdose, HIV, hepatitis C, addiction, and incarceration.

Al-Anon: www.al-anon.alateen.org, 1-888-4AL-ANON (425-2666)

For over fifty years, Al-Anon (which includes Alateen for younger members) has offered hope and help to families and friends of alcoholics.

Sexual and Reproductive Health

Scarleteen: www.scarleteen.com

Provides sex and sexuality education, information and advice for millions of young adults, parents and allies, and is one of the most widely used and longstanding sex education websites despite never having any public funding or corporate affiliation.

Teenwire: www.teenwire.com, 1-800-230-PLAN

Planned Parenthood's sex, sexuality, relationship, and health website for teens and young adults with information in English and Spanish.

Planned Parenthood: www.plannedparenthood.org, 1-800-230-PLAN (7526)

The nation's leading women's health care provider, educator and advocate. Information on birth control, emergency contraception, and pregnancy options.

Pregnancy Options: www.pregnancyoptions.info

Provides information on pregnancy options including abortion, adoption, childbirth and parenting.

Queer mental health

PRIDE Institute: www.pride-institute.com, 1-800-54-PRIDe (547-7433)

The nation's first and leading provider of in-patient and out-

patient programs devoted exclusively to treating the mental health and chemical dependency needs of the lesbian, gay, bisexual and transgender community. They specialize in the treatment of drug and alcohol addiction, sex addiction, depression, and anxiety.

Lavender Youth Recreation and Information Center:
lyric.org, 1-800-246-PRIDE (246-7743)

Offers education enhancement, career trainings, health promotion, and leadership development for lesbian, gay, bisexual, transgender, queer, and questioning youth, their families, and allies of all races, classes, genders, and abilities. The free and anonymous Youth Talkline/Infoline provides peer support, health and sexuality information.

OutProud: www.outproud.org

OutProud is The National Coalition for Gay, Lesbian, Bisexual & Transgender Youth. They provide advocacy, information, resources and support in order to help queer youth become happy, successful, and confident.

GLBT National Youth Talkline: www.glnh.org/talkline,
1-800-246-PRIDE (Hours: Monday-Friday from 5pm to 9pm,
Pacific Time), youth@GLBTNationalHelpCenter.org

The GLBT National Youth Talkline provides free and confidential telephone and e-mail peer counseling, as well as factual information and local resources for cities and towns across the United States. Telephone volunteers are in their teens and early twenties, and

speak with teens and young adults up to age twenty-five about coming-out issues, relationship concerns, parent issues, school problems, HIV/AIDS anxiety and safer-sex information.

ART RESOURCES

Photography

Online Photo Share: Flickr.com, Deviantart.com
Post your work on the internet for critique, response, and promotion.

Cartooning

Friends of Lulu: www.friends-lulu.org
A national nonprofit organization whose purpose is to promote and encourage female readership and participation in the comic book industry.

Writing

The Global Girl Zine Network: http://grrrlzines.net
A global network of grrrl zinesters. Post your zine and discuss feminist theory, politics and activism.

Feminist Bookstores:

http://users.rcn.com/seajay.dnai/fbn/stores/stores.html

Find a feminist bookstore near you. Most of them have message boards or at least can keep you updated about kick ass women artists coming through town.

Find an Open Mic: openmikes.org

Perform at a local open mic night.

Journalism

Blog: www.livejournal.com, www.blogger.com

Share your thoughts with the world by starting your own blog.

The Women's Media Center: www.womensmediacenter.com

Works to ensure that women are represented as local, national, and global sources for and subjects of the media, and that women media professionals have equal opportunities for employment and advancement.

Women In Media & News: www.wimnonline.org

The media analysis, education and advocacy group works to increase women's presence and power in the public debate. The Power Sources Project provides journalists with a diverse network of female experts.

Women's E-news: www.womensenews.org

Women's eNews editors seek out freelance writers from around the world to write on every topic—politics, religion, economics, health, science, education, sports, legislation—and commission them to write 800-word news articles for distribution each day to our subscribers and for posting on our website.

Music

Find an Open Mic: openmikes.org

Perform at a local open mic night.

Myspace: www.myspace.com

Record your own music and then post it to get feedback.

Rock 'N' Roll Camp for Girls: www.girlsrockcamp.org

Builds girls' self-esteem through music creation and performance. Provides workshops and technical training in order to create leadership opportunities, cultivate a supportive community of peers and mentors, and encourage the development of new skills.

Film

Youtube: www.youtube.com

Make a short film and post it.

Independent Women Filmmakers:

www.independentwomenfilmmakers.com

An international group of production assistants, screenwriters, actors, directors, cinematographers, editors, film students and other film industry amateurs and professionals.

Playwriting

Playwriting Opportunities: www.playwritingopportunities.com

Check out what playwriting contests or classes might be up your alley.

International Centre for Women Playwrights:

http://www.netspace.org/~icwp/

Seeks to bring international attention to women playwrights, encouraging production of their plays, providing means for communication and contact among the sister community of the world's women dramatists, and assisting women in developing as playwrights.

Burlesque

Burlesque: Burlesquebitch.com

An information center for all things burlesque.

Comedy/Performance Art

Open Mic: comedy.openmikes.org
 Perform at a local open mike night.

Chuckle Monkey: www.chucklemonkey.com
 The comedy resource website with free reference materials and club, open mike and other booking information.

Franklin Furnace: www.franklinfurnace.org
 Franklin Furnace is dedicated to serving artists by providing both physical and virtual venues for the presentation of time-based visual art, including but not limited to artists' books and periodicals, installation art, performance art, and live art on the Internet.

Radical Cheerleaders: radcheers.tripod.com
 Get some pom-poms and join or start your very own radical cheerleading team and learn how to become a cheerleading activist.

FUNDING

The Fund for Women Artists: www.womenarts.org/fund
 Website offers help finding financial and other resources to sustain your art.

Acknowledgments

First off, I have to thank the contributors for sharing their stories with candor, honesty and heart. It has been a privilege to work with each of you.

This book would not have been possible without Crystal Yakacki, who was the driving force behind it at Seven Stories. Crystal, you're incredible and thank you. Additional thanks to Theresa Noll, Amy Scholder, Matt Hannah, and to the team at Seven Stories for taking a chance on this book, and for their help whenever I stopped by. Thanks to Kate Bornstein for putting me in touch with Seven Stories, and Carol Queen for putting me in touch with Kate.

Bluestocking is a great nonprofit bookstore in New York. Much of the book was worked on and realized there. Major thanks to Jeffrey and the Bluestocking collective for recommending people, and simply hearing me out.

Christina Turley is disco. What else can I say? Eternal love and thanks to those in PMQ and Savannah, as well as Andrea Nott, Hope Hoffman, and Adam Reitzel. Dave Sanders is great. And thanks to Jenn Dickman, David Ames, and Adriene Tynes who provided editorial eyes, inspiration, and love on a constant basis.

Final thanks to my family for their love and constant support. The incomparable Magdalena Bueno (Maggie Chapadjiev) who is the strongest woman I know, and Shefket Chapadjiev, my dad, who

is incredible and I love so very much. Sammy for being a little light in my heart, and my sister Sophia for all that can't be put into words.

SABRINA CHAPADJIEV is a musician, playwright, spoken word artist and sometimes editor. Her previous collection, *Cliterature: 18 Interviews with Women Writers* was featured on the International Museum of Women's online exhibition. Her plays *perhaps merely quiet, the Insatiable Lite Duet*, and *Security*, as well as various ten-minute plays, have been produced in Chicago, New York, Paris, London and Malmo, Sweden. Currently, she is concentrating on her music—no, really this time—and recording her first album before she gets sucked into any more projects. Visit her at www.sabrinachap.com.

ABOUT SEVEN STORIES PRESS

Seven Stories Press is an independent book publisher based in New York City, with distribution throughout the United States, Canada, England, and Australia. We publish works of the imagination by such writers as Nelson Algren, Russell Banks, Octavia E. Butler, Ani DiFranco, Assia Djebar, Ariel Dorfman, Annie Ernaux, Barry Gifford, Almudena Grandes, Elfriede Jelinek, Peter Plate, Lee Stringer, and Kurt Vonnegut, to name a few, together with political titles by voices of conscience, including the Boston Women's Health Book Collective, Noam Chomsky, Angela Davis, Stuart and Elizabeth Ewen, Coco Fusco, Martin Garbus, Human Rights Watch, Ralph Nader, Gary Null, Project Censored, Paul Robeson, Jr., Barbara Seaman, Gary Webb, and Howard Zinn, among many others. Our books appear in hardcover, paperback, pamphlet, and e-book formats, in English and in Spanish. We believe publishers have a special responsibility to defend free speech and human rights, and to celebrate the gifts of the human imagination, wherever we can.

For more information, visit our Web site at www.sevenstories.com, or write for a free catalogue to Seven Stories Press, 140 Watts Street, New York, NY 10013.